ST HELIER
THROUGH TIME
Keith E. Morgan

AMBERLEY

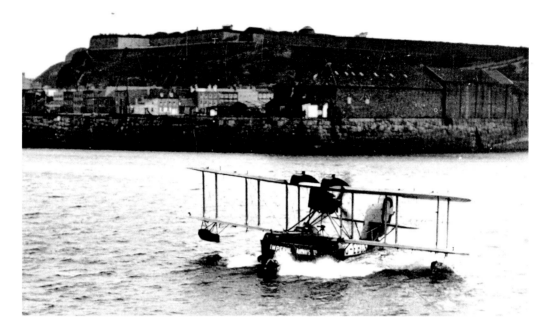

Flying Boat in St Helier Harbour, *c.* 1924
Imperial Airways Supermarine Sea Eagle amphibious flying boat *G-EBGS* taxiing in Jersey Harbour. A single engined bi-plane with a crew of two and six passengers, it was one of three built for the Channel Islands passenger route. Inaugurated on 25 September 1923, it was the first British and world scheduled passenger air service by flying boat. *G-EBGS* was rammed by a ship in St Peter Port, Guernsey, in January 1927 and the route closed in 1929.

This book is dedicated to Malvina, 'My Special Angell', with whom I spent many happy and memorable holidays in Jersey.

First published 2012

Amberley Publishing
The Hill, Stroud
Gloucestershire, GL5 4EP

www.amberley-books.com

Copyright © Keith E. Morgan, 2012

The right of Keith E. Morgan to be identified as the Author of this work has been asserted in accordance with the Copyrights, Designs and Patents Act 1988.

ISBN 978 1 4456 0054 3

British Library Cataloguing in Publication Data.
A catalogue record for this book is available from the British Library.

Typeset in 9.5pt on 12pt Celeste.
Typesetting by Amberley Publishing.
Printed in the UK.

Introduction

This is the first book in a two-part series that traces Jersey's history using photographs as the main media. This, the first book, covers the town and capital of St Helier itself, while the second book embraces the remainder of the island. The format of the two books is identical; an old view is compared with a modern view, preferably photographed from the same vantage point as the original. However, it has not been possible in all cases to replicate an exact view of a location due, for example, to building development or mature growth of trees. Also, use has been made of sketches and drawings where photographs have not been available. The reader is taken on a circular journey that starts from the harbour and travels in an anti-clockwise direction around the town before returning to the seashore.

As to the origins of St Helier, it is thought that there was a settlement on the site during the Roman period, although there is very little archaeological evidence available to confirm this. What is known, however, is that the town is named after Helier, a Belgian saint and hermit who lived for some ten years on an offshore islet in St Aubin's Bay, now called the Hermitage. He was killed in AD 555 by Saxon pirates and was subsequently martyred. As such, St Helier was adopted as the patron saint of Jersey, its church and its capital. At this early time, St Helier was probably just a small fishing village located on the dunes between the marshy land behind and the high-water mark.

Thought to have been sited on an earlier chapel, the construction of the present parish church began in the eleventh century. Although someway inland today, the parish church once lay on the seashore. At one time there were iron rings set in the churchyard walls on the seaward side, in order to tie up boats. These were lost when land reclamation and port construction started and when the south end of the church was extended during one of many changes made to the building. The church also used to house the Parish Gun or Cannon.

In 1155, the Abbey of St Helier was founded on L'Islet, a tidal island adjacent to the Hermitage. After it was closed during the Reformation, the abbey was fortified to create the castle that was to replace Mont Orgueil as the island's major fortress. This new fortification was named Elizabeth Castle by Sir Walter Raleigh, who was Governor of Jersey 1600–03. Charles II took refuge in Elizabeth Castle in 1646 during the Civil War and it was here that he was proclaimed king in 1649. In gratitude for the support that he had received during his exile, King Charles II subsequently gave to Jersey land in the new world, which eventually became New Jersey.

Until the end of the eighteenth century, the town consisted chiefly of a string of houses, shops and warehouses stretching along the coastal dunes. This habitation extended either side of the parish church of St Helier and the adjacent marketplace. The latter was called Le Marchi and was also the site of the courthouse. The market cross was pulled down during the Reformation and the iron cage for holding prisoners awaiting transportation to Mont Orgueil, was replaced in 1688 by a prison gatehouse located at the west entrance to town called Charing Cross.

In 1751, the market place was renamed Royal Square and a gold statue of King George II was erected in gratitude to His Majesty, who had given £200 towards the construction of a new harbour. Previously, boats had beached on a falling tide for loading and unloading by cart across the sands. The courthouse was rebuilt as the States Building to accommodate the Royal Court and States Chambers. The Royal Square was the scene of the Battle of Jersey, the last attempt by the French to seize the island. Here on 6 January 1781, Major Peirson, in command of the Jersey Militia, vanquished the French invaders. In doing so, he was mortally wounded and died a national hero. As a result of continuing military threat from France, the citadel fortress of Fort Regent on the Mont de la Ville was constructed between 1804 and 1812.

Harbour construction and development started apace in 1841 when both the Victoria and Albert Piers were built. It was at the former that Queen Victoria landed for her visit to Jersey in 1846. Military roads, which had been built to link coastal defences around the island with St Helier harbour, now enabled farmers to exploit Jersey's temperate climate. By fast sailing ship, and then later by steamship, the farmers were able to get their produce into the markets of London and Paris earlier than the competition. This was the start of Jersey's nineteenth-century agricultural prosperity. Roads were widened to accommodate the increased harbour traffic, sewerage and freshwater systems were implemented and there was an influx of English-speaking residents that encouraged further development of the town of St Helier.

From the 1920s there has been a busy cross-channel passage by sea and from 1933 a scheduled air service operated from the beach at West Park, until the purpose-built airport was eventually constructed at St Peter's in 1937.

Following the end of the occupation of the island during the Second World War, development has moved forward in leaps and bounds. Tourism took off in the late 1950s, La Collette Electricity Power Station was built in 1965 and in 1970 a road tunnel was cut through the solid rock beneath Fort Regent, with an accompanying pedestrianisation of central town streets. Elizabeth Harbour and Elizabeth Marina were opened respectively in 1989 and 1998 and the ongoing Waterfront development began in 2007. All of which developments have contributed to making St Helier today a very busy and prosperous port and capital town.

Keith E. Morgan

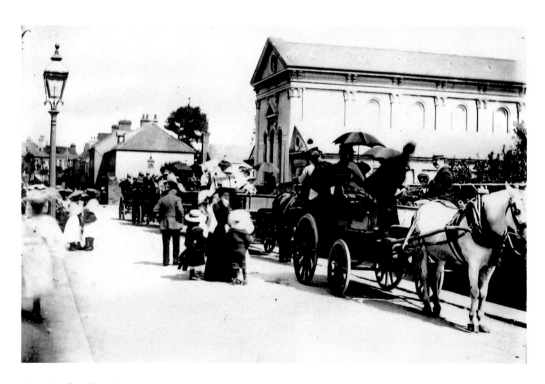

Don Road in the 1890s.

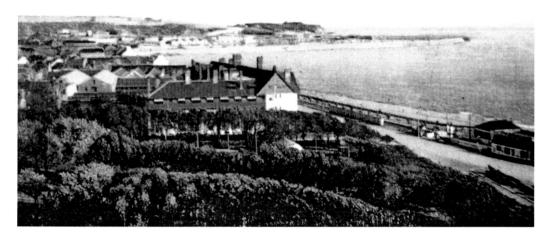

St Helier Then and Now

Looking east over St Helier in a picture taken from Westmount sometime after the Foundation Stone of the Grand Hotel was laid in 1890. The same view in 2011 shows the extent of the land reclamation and development that has taken place on the foreshore and at the harbour in the intervening years, especially since the end of the Second World War.

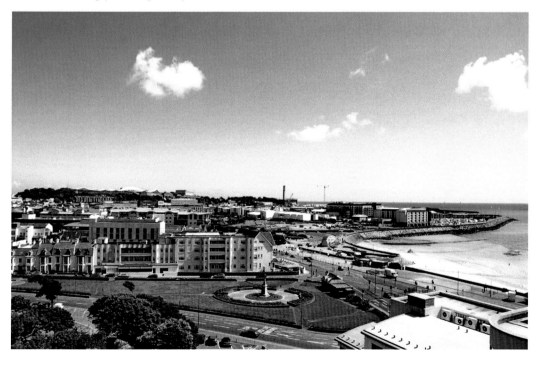

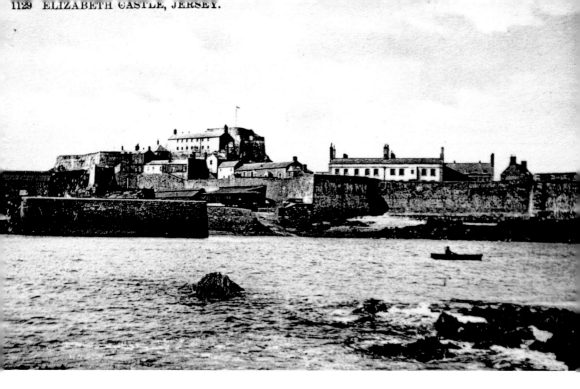

Elizabeth Castle, *c.* 1900 and 2011
The impressive edifice that meets your eye when you enter St Helier Harbour by sea. Except for the German concrete fortifications added during the occupation, not much has changed in the corresponding view that we see today.

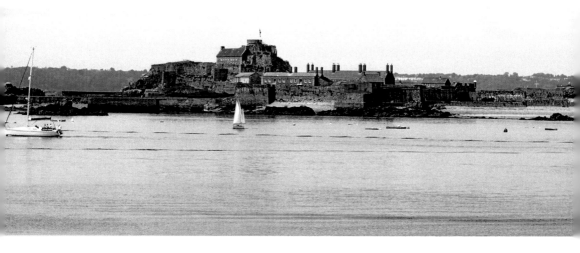

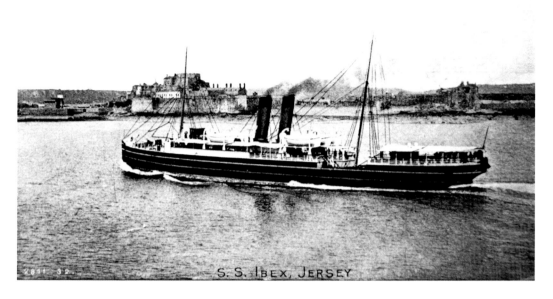

The SS *Ibex, c.* 1922, and SS *Isle of Sark,* 1932

The GWR SS *Ibex* was one of the most noted and ill-fated ships ever built for the Channel Islands service. The ship plied between Jersey, Guernsey and Weymouth from 1891 to 1923. In contrast, the Southern Railway's oil burning steamer, the SS *Isle of Sark,* was the third of the 'Isle' class vessels built for the route in 1932. A radar training ship in the Second World War, she was the first mailboat to be fitted with radar and remained in service until 1960.

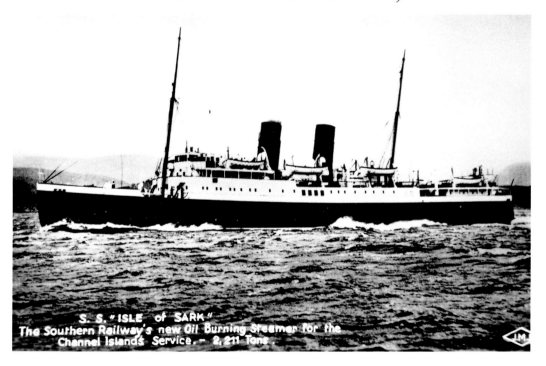

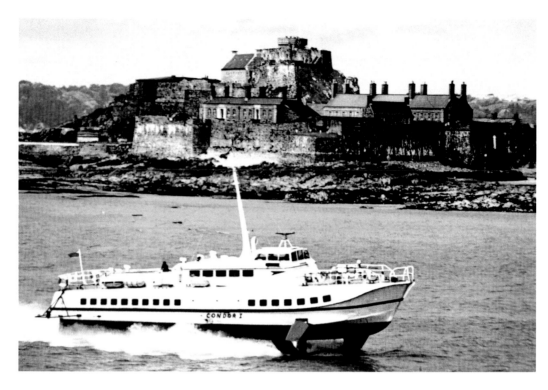

Condor I Hydrofoil and Condor Express High-Speed Catamaran
The Condor I Hydrofoil fast ferry with a speed of 33 knots, was built in 1964 and used until 1976 to carry up to 140 passengers between the Channel Islands and St Malo. Not much faster at 38 knots, but much bigger, the Condor Express shown in the same view in 2010, can carry 742 passengers and 175 vehicles and is one of three catamarans that currently provides a fast ferry Channel Islands service.

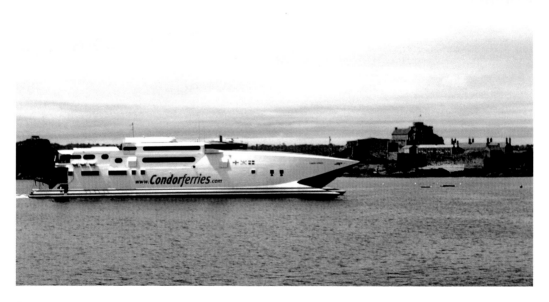

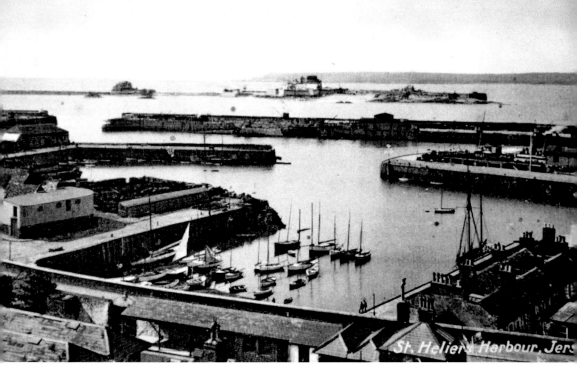

St Helier Harbour in the Days of Sail, *c.* 1900
Two views showing the development of St Helier Harbour in the days of sail. La Folie Inn can be seen quite clearly to the middle-left.

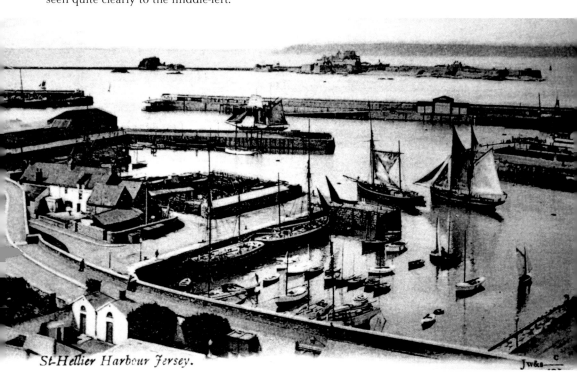

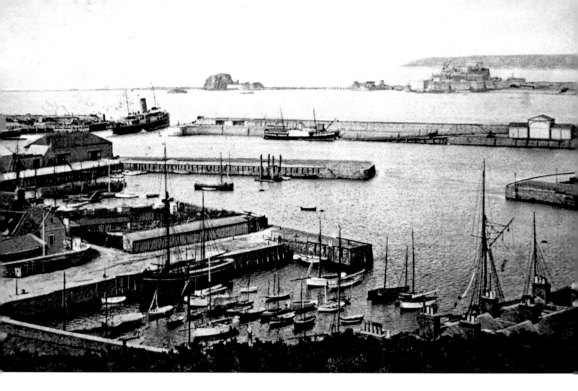

Development of St Helier Harbour, *c.* 1890 and 2011
Contrasting views from South Hill that show St Helier Harbour *c.* 1890 and today.

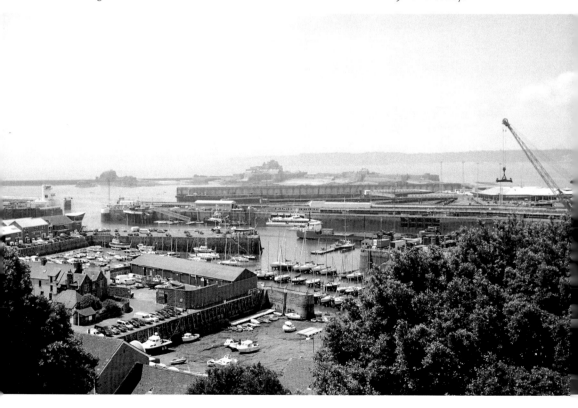

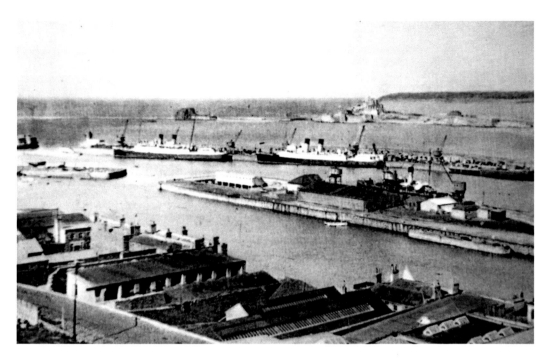

St Helier Harbour, 1933 and 2011
A panoramic view of St Helier Harbour in 1933 showing the development that had taken place prior to the Second World War. The two vessels berthed at Albert Pier are in all probability, the *Isle of Sark* and the *Isle of Jersey*. In contrast, the modern photograph shows the extensive development carried out over the last sixty years, with new buildings springing up and the construction of the new Elizabeth Harbour and Marina.

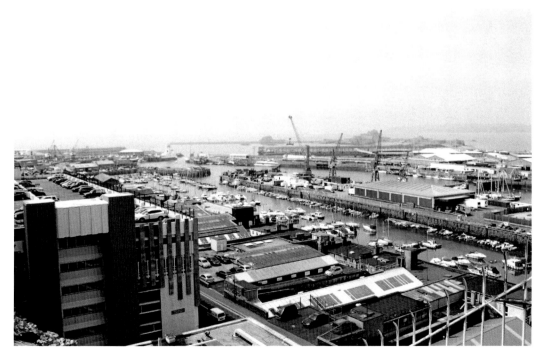

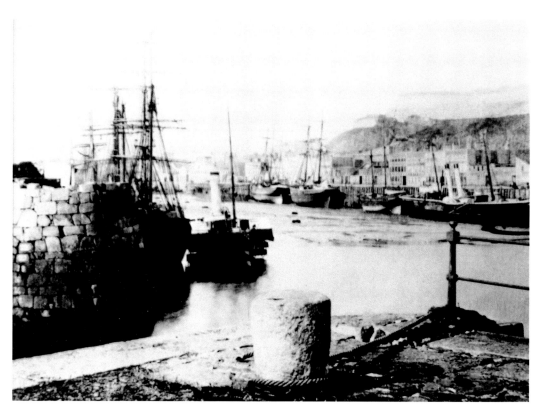

St Helier Harbour, *c*. 1885 and 2011
Again, two contrasting views of English Harbour and the Old Harbour, this time showing the change that has taken place over the years, with the emphasis on moving from merchant shipping to pleasure craft.

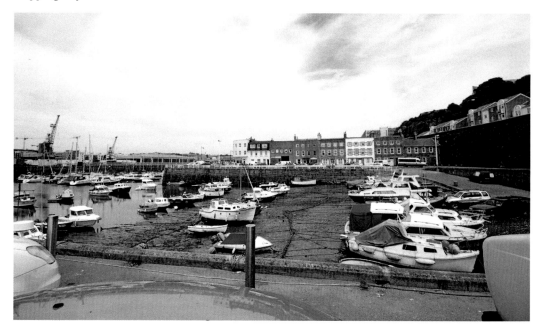

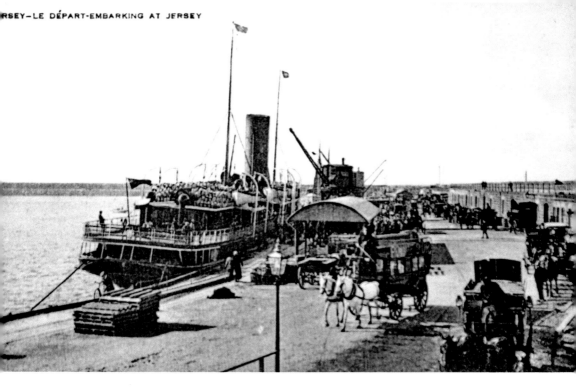

Disembarking at Albert Pier, St Helier Harbour, c. 1900
Passengers disembarking an unidentified ship at Albert Pier. Local hotels had their own transport
to pick up guests at the pier; in the foreground, the coach with the two white horses is from the
Pomme D'Or Hotel.

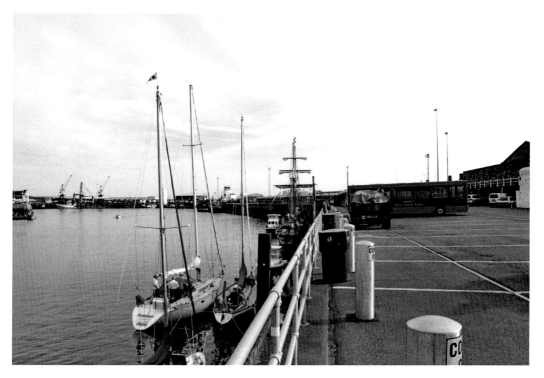

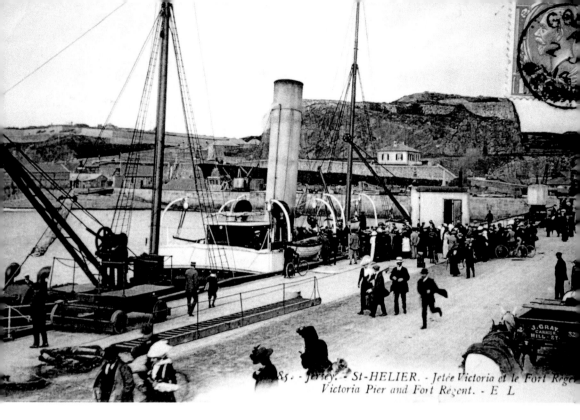

Passengers Embarking at Victoria Pier, 1914
A view of Victoria Pier with Fort Regent in the background. Again the ship is unidentifiable in this postcard, which has been franked 'Gorey 2 JU 14'.

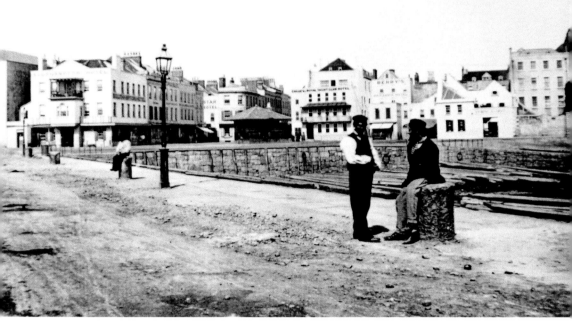

Weighbridge, 1880
A picture taken when the Old Harbour extended further north into Weighbridge Place. This part of the harbour was filled in many years ago and today this area is bustling with traffic.

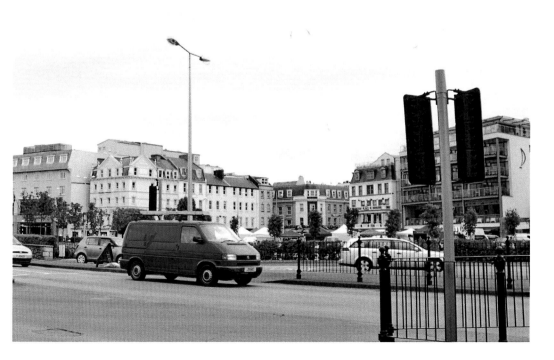

15

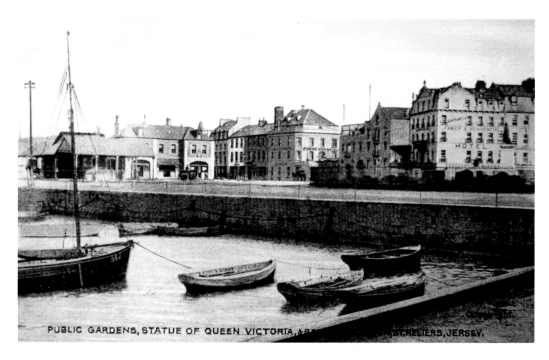

PUBLIC GARDENS, STATUE OF QUEEN VICTORIA, & ... ST.HELIERS, JERSEY.

Weighbridge, After 1890

Weighbridge and the Old Harbour with Queen Victoria's statue and gardens on the right of this postcard view. The statue was erected and the garden laid in 1890. Later they were both removed and the north end of the Old Harbour filled in to make way for development. The latter then became the bus terminal, which in turn has now become a leisure area where boule ball is played on a number of pitches or courts.

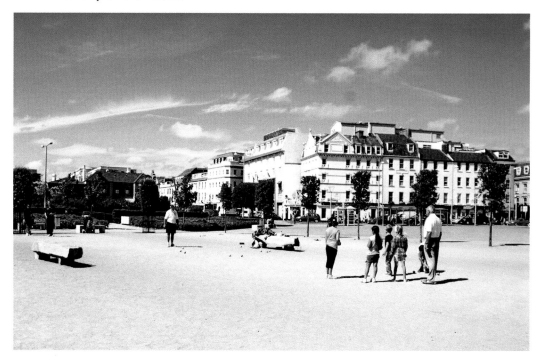

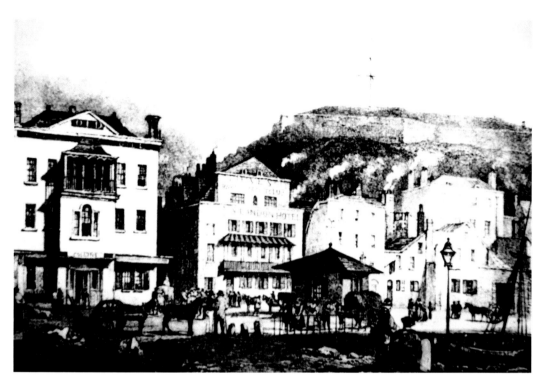

Caledonia Place, c. 1850 and 2011
A lithograph of c. 1850 with a view of the properties on Caledonia Place under the domination of Fort Regent. Even after development, some of these properties are still recognisable in the 2011 photograph.

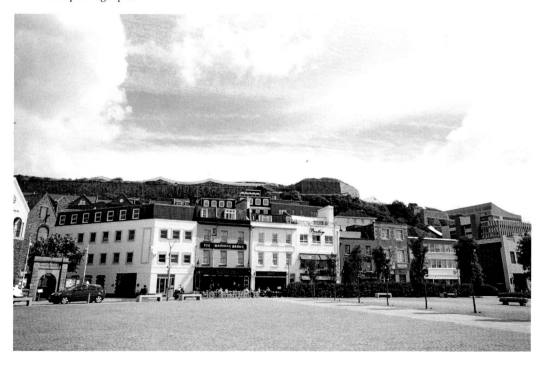

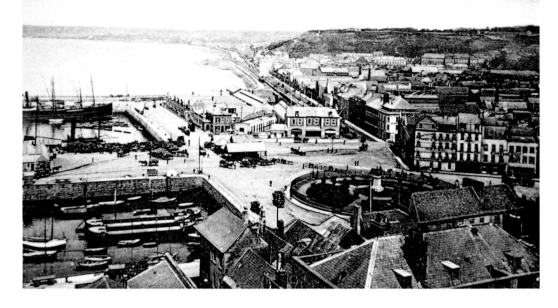

JERSEY-VUE GÉNÉRALE DE ST. HÉLIER-GENERAL VIEW OF ST. HÉLIER

Weighbridge from Fort Regent, c. 1900 and 2011
Still in the age of sail, but after 1890 when Queen's Victoria's statue was unveiled. The statue was eventually moved to Victoria Park and the north end of the Old Harbour filled into make way for development. The latter has in turn made way for the new road system accessing the road tunnel under Fort Regent. Inset: The Liberation Sculpture by Philip Jackson, erected in 1995 to celebrate the fiftieth anniversary of the liberation of Jersey.

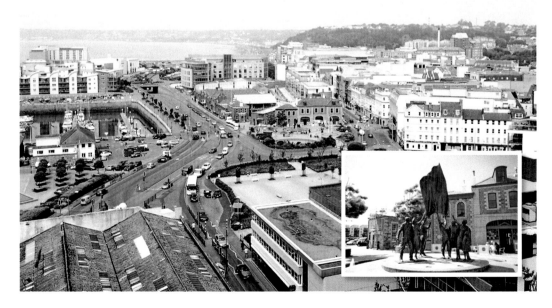

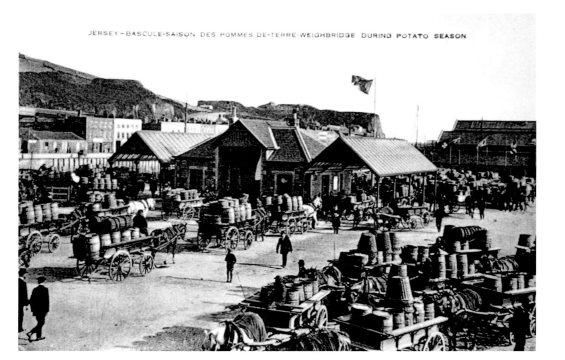

Weighbridge at the Height of the Potato Season, *c.* 1900
A busy scene at the Weighbridge, where Jersey vans are arriving loaded with new potatoes for export. The Weighbridge has gone and the same site is more or less occupied by the steam clock, the 'Ariadne'. The steam clock was designed in 1999 by Gordon Young as a millennium project. It is operated by a refurbished 1895 steam engine and is the largest of its kind in the word.

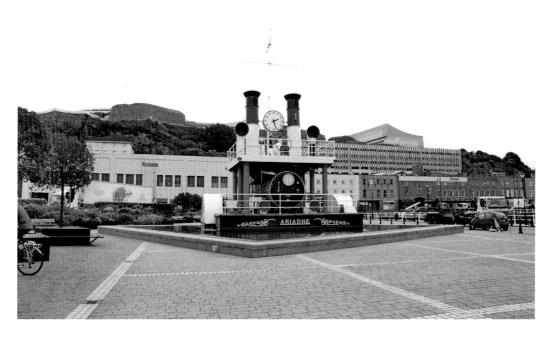

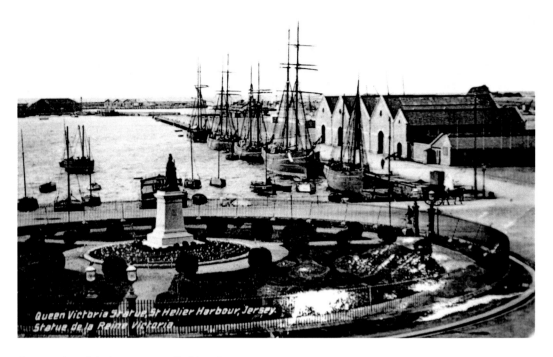

Queen Victoria's Statue, Unveiled in 1890

A postcard view produced in 1890 not long after Queen Victoria's statue was unveiled and the gardens were created. The statue was subsequently removed and in 1924 the north end of the Old Harbour was filled in to become a car park, with the latter in turn making way for road widening. The sheds have been converted to house the Maritime Museum and Occupation Tapestry, while the open area to the foreground of the 2011 view is used for the playing of boule ball.

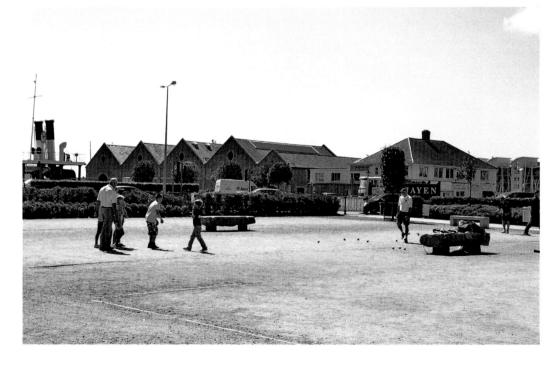

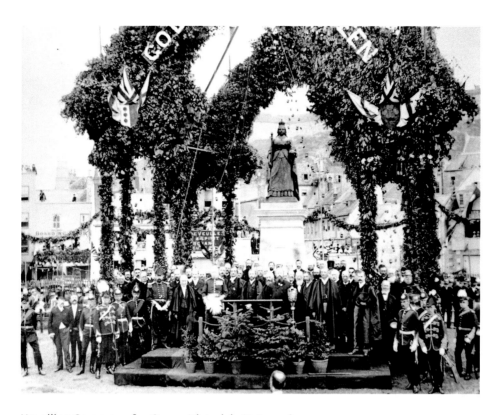

Unveiling Ceremony for Queen Victoria's Statue, 1890
The unveiling ceremony of Queen Victoria's statue at Weighbridge Place in 1890 and the present position of the statue in Victoria Park with the Grand Hotel forming an impressive background.

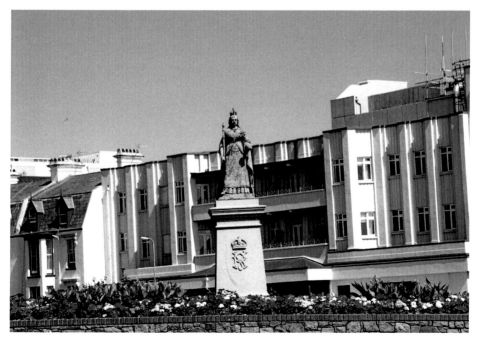

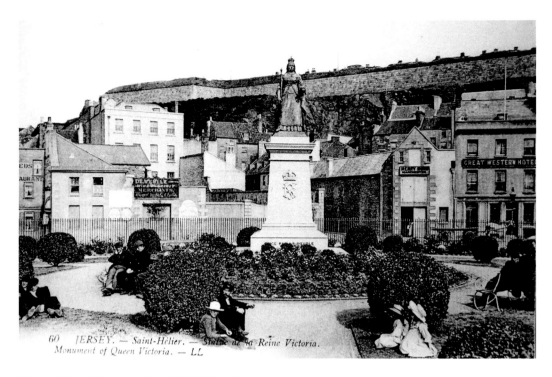

60 JERSEY. — Saint-Hélier. — Statue de la Reine Victoria.
Monument of Queen Victoria. — LL

Queen Victoria's Statue in Weighbridge Place

Queen Victoria's statue and gardens in Weighbridge Place not long after it was unveiled in 1890. The statue was moved to Victoria Park in 1976 to make way for a car park and road extensions. The whole of Weighbridge Place is now an open area used for food markets and the playing of boule ball.

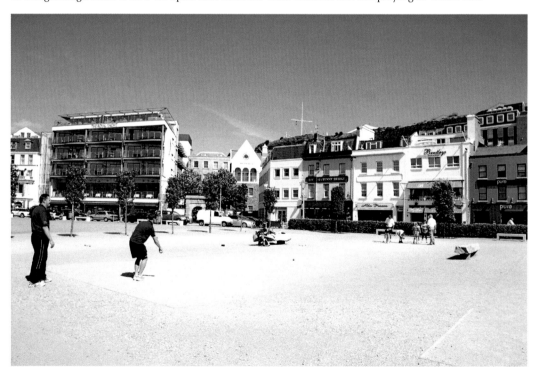

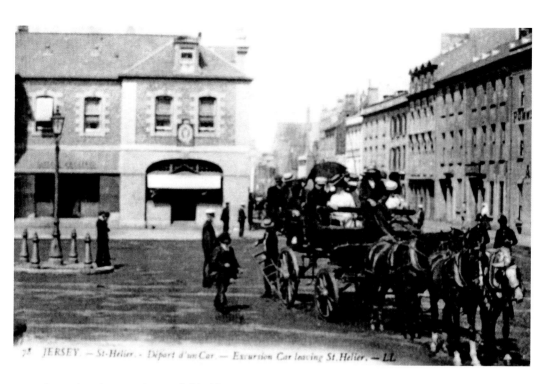

Excursion Car Leaving Weighbridge, c. 1914 and 2011

The building in the background is the terminus of the Jersey Railway, built in 1901 and a good focal point for the start of tours of the island. The Jersey Railway has long gone, but 'excursion cars' such as Tantivy Blue Coaches still start their tours from this location.

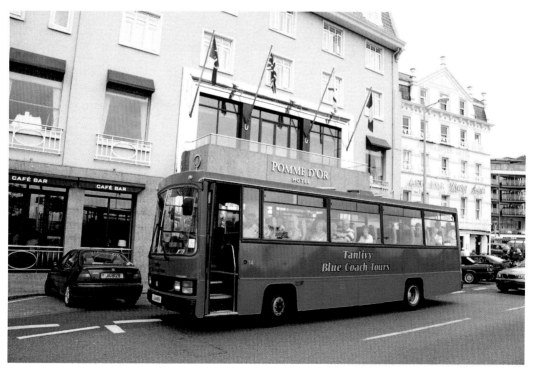

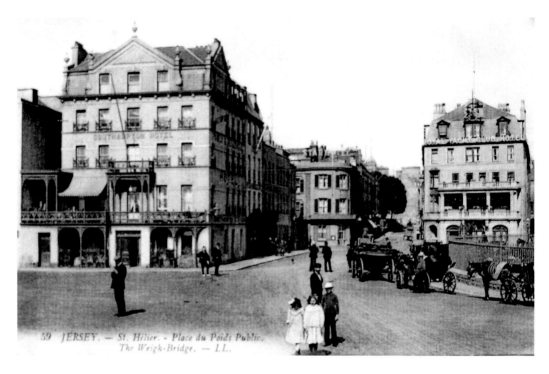

59 JERSEY. — St. Hélier. - Place du Poids Public.
The Weigh-Bridge. — LL.

Weighbridge Cab Rank, After 1899

The horse-drawn cab rank is in front of Caledonia Place, with the Royal Yacht Hotel behind. This hotel was established as early as the 1820s, while P. McAllen's Elephant and Castle Hotel on the opposite side of Mulcaster Street was built in about 1895. The Southampton Hotel on the left of the photograph, according to the masonry inscription on its apex, was rebuilt in 1899. Not too much has changed in today's photograph except that the Pomme D'Or Hotel, on the extreme left, has increased in height.

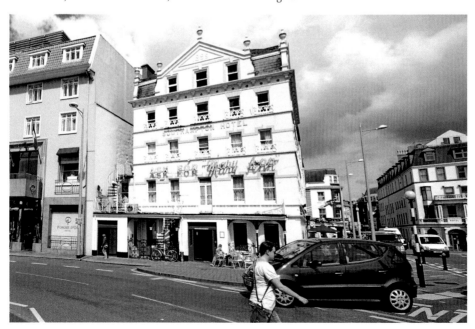

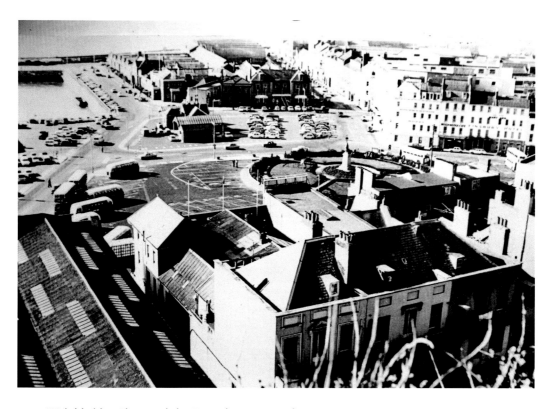

Weighbridge Place and the Tunnel, *c.* 1975 and 2011
A view of Weighbridge from Pier Road before Queen Victoria's statue was moved in 1976. Subsequently La Route de la Liberation was built and extended east through the rock of Fort Regent by the construction of a road tunnel, completed on 31 May 1970.

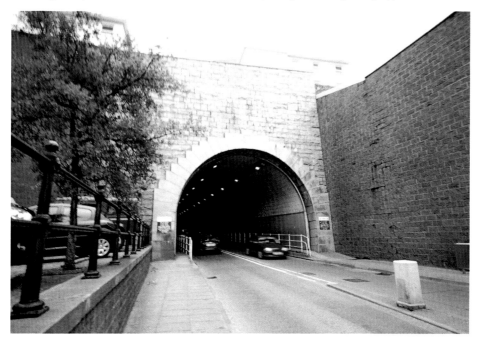

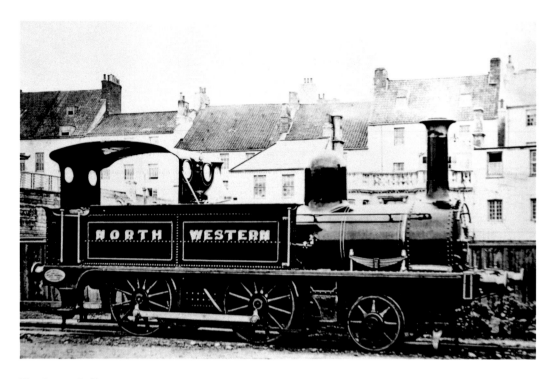

The Jersey Railway

Opened in 1870, the Standard Gauge Jersey Railway initially ran from St Helier to St Aubin. Locomotive *North Western* 2-4-0 was one of the engines that operated on this route. It was eventually sold to the Jersey Eastern Railway in 1878, prior to the line being converted to narrow gauge in 1884. The railway has long gone, but today we have the Petit Road Train to carry on the tradition.

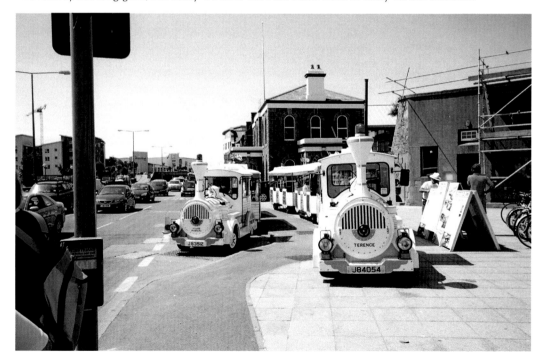

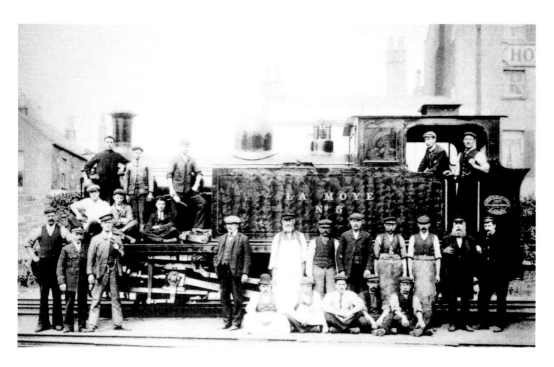

Jersey Railway Locomotive *La Moye* No. 5
Locomotive *La Moye* No. 5, a 2-4-0 built in 1907, at St Helier Terminal with driver, fireman and what appear to be all the footplate men. In contrast, in the modern view we have the road train leaving the old terminal building to wend its way through the streets of St Helier *en route* to St Aubin.

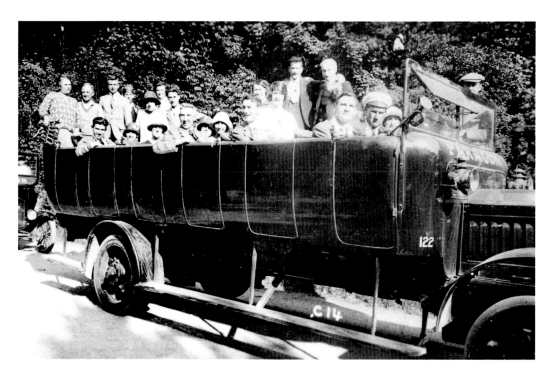

Charabancs Then and Now
A Jersey Paragon Gordon Bennett charabanc of *c.* 1914 and a modern version, first introduced in 2011.

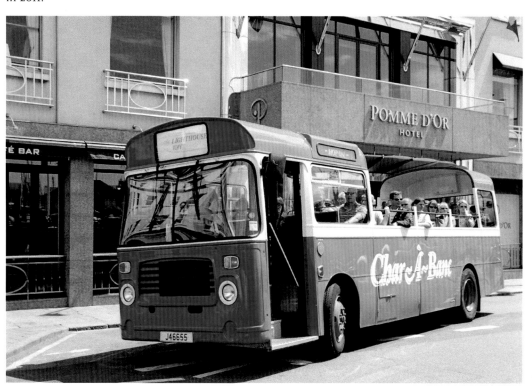

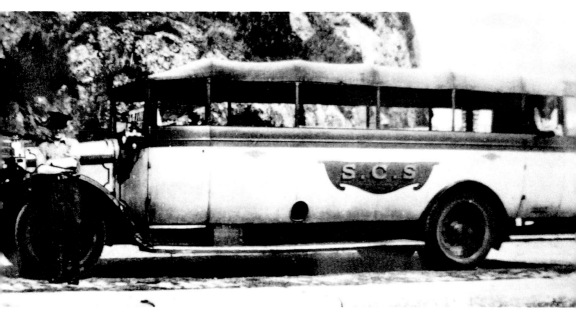

SCS Charabanc of 1932
An example of an SCS charabanc of 1932, compared with the modern service buses at the new bus station, provided by Connect.

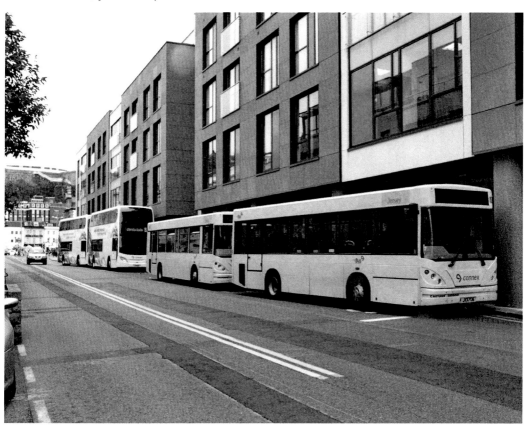

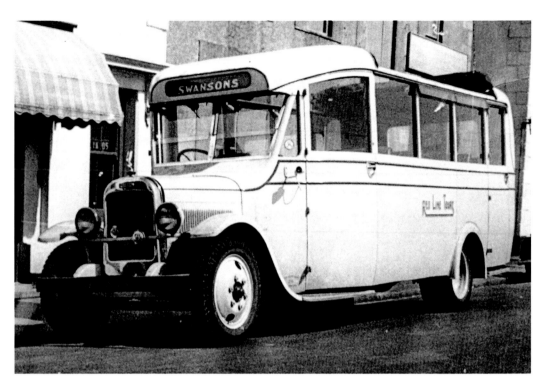

'Federal' of Red Line Tours, *c*. 1935
Compare this 'federal' vehicle of *c*. 1935 with the swish new double-decker buses, introduced in 2011 to provide a service between St Helier and the airport.

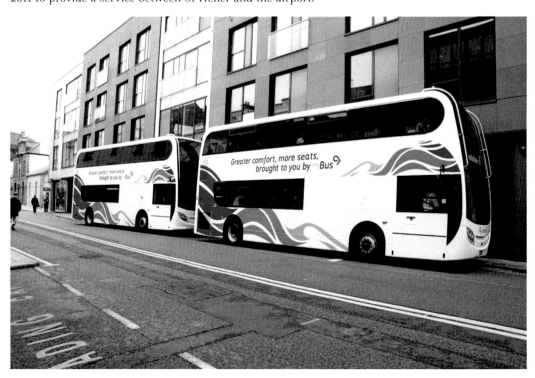

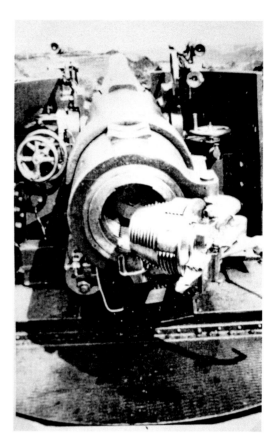

Le Petit Mont de la Ville, Pre-1928
One of the 6-inch guns on Le Petit Mont de la Ville, a fortified outwork of Fort Regent named South Hill Battery. The latter is situated on the top of the southern extremity of Mount Bingham with a commanding view over the harbour approaches. The 6-inch guns were removed in 1928 when the land was given to St Helier, but the gun emplacements were re-fortified by the Germans during the occupation.

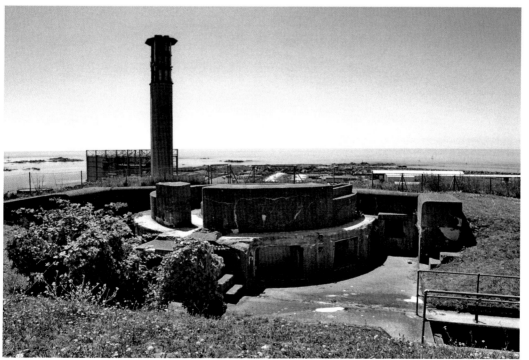

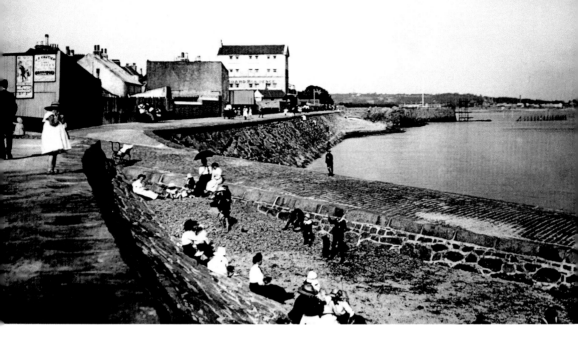

Havre Des Pas, c. 1900
An early postcard view of Havre Des Pas from about 1900. Today's photograph shows the development that has taken place over the intervening years.

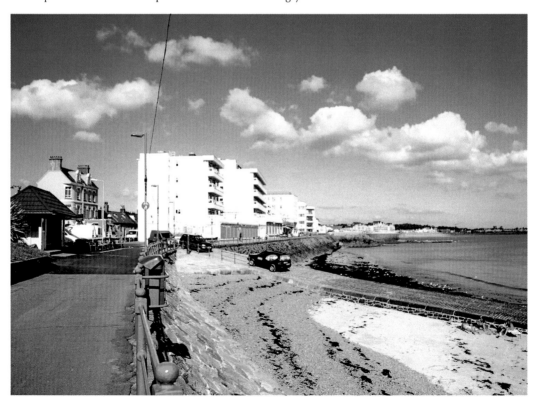

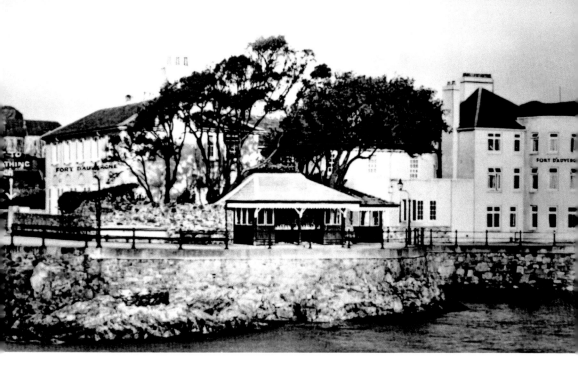

Hotel Fort D'Auvergne, c. 1900 and 2011
A comparison of the two views illustrates the development that has taken place on the Boulevard at Havre Des Pas. However, it is still possible to identify the shelter and the Hotel D'Auvergne as these have changed very little over time.

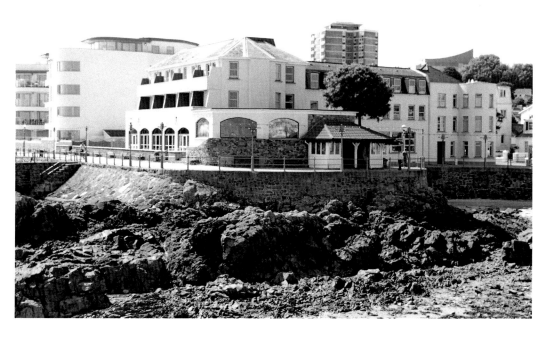

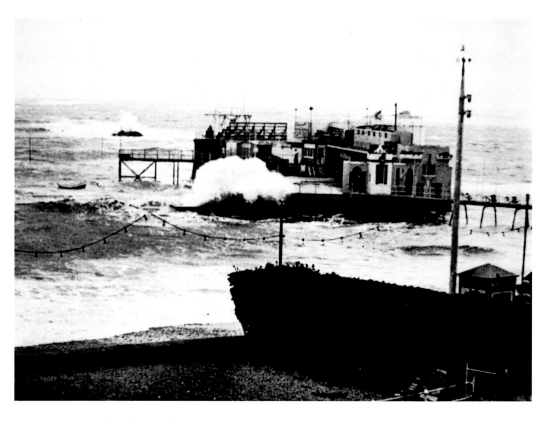

Havre Des Pas Swimming Pool, 1920s
The Havre Des Pas swimming pool being buffeted by high stormy seas, sometime in the 1920s.

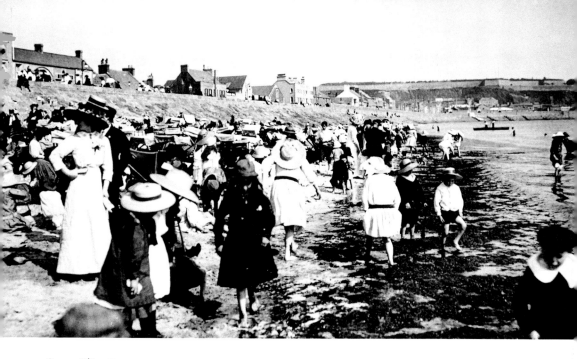

Greve D'Azette, *c.* 1900
What a comparison between the crowded beach of the early 1900s and the scene captured by the photographer in July 2011.

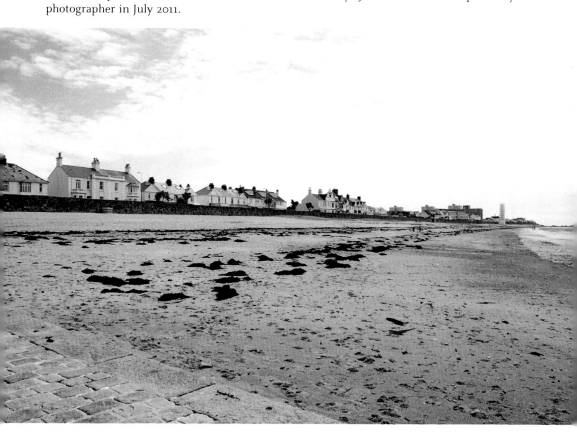

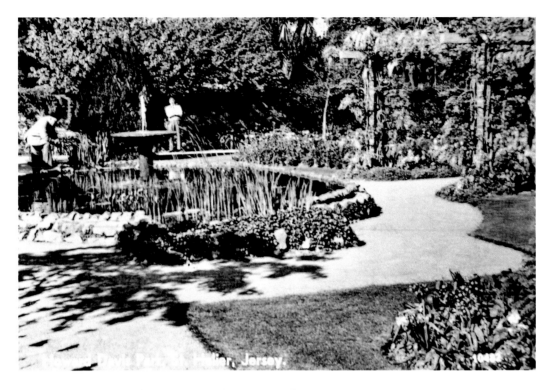

Howard Davis Park The Rose Garden, 1939 and 2011
A bequest of Jerseyman Thomas Benjamin Davis to St Helier, the Howard Davis Park was opened in 1939, in memory of his son Howard Leopold Davis who was killed at the Battle of the Somme in 1916. The park sits in the centre of a complex of busy major roads. However, once inside the 10-acre park, there is an air of tranquillity with almost total seclusion from the outside world.

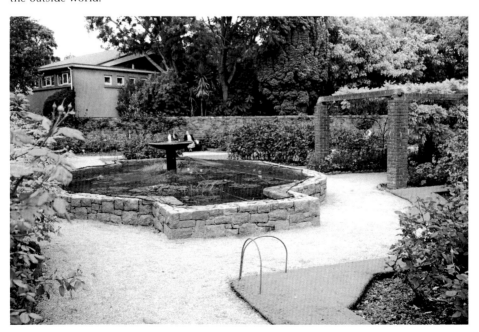

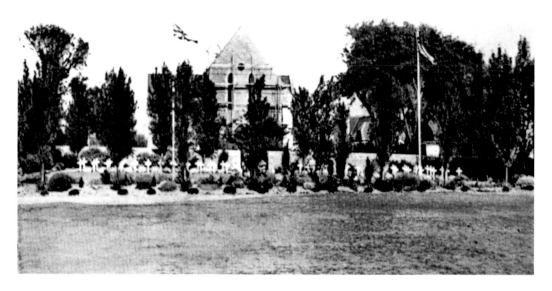

Allied War Cemetery, Howard Davis Park, 1943 and 2011
On 3 October 1943, HMS *Charybdis* was sunk off the Guernsey coast. Many bodies were washed ashore on Jersey and it was decided by the States of Jersey to bury these, together with other Allied servicemen, in a plot of land in the Howard Davis Park. This plot was dedicated as the Allied War Cemetery by the Dean of Jersey on 26 November 1943 and is maintained in an immaculate condition today.

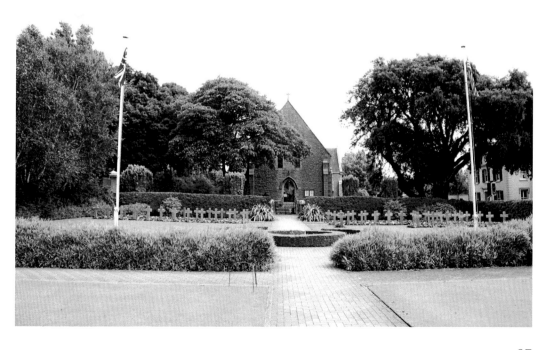

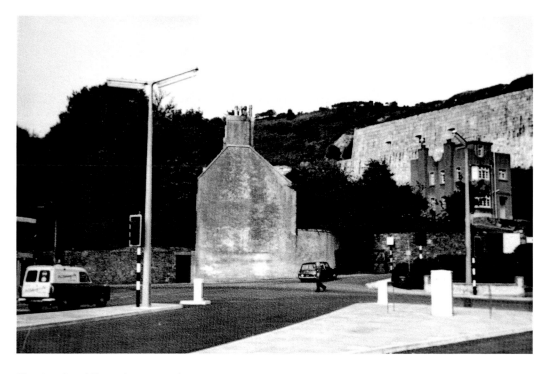

The A17 Road Tunnel, 1970 and 2011
Cut through the solid rock beneath Fort Regent, this road tunnel was completed on 31 May 1970 and connects Weighbridge Place with Green Street. Views show the Green Street end before and after completion of the tunnel.

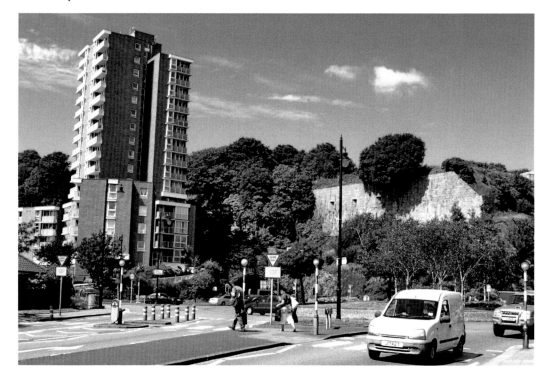

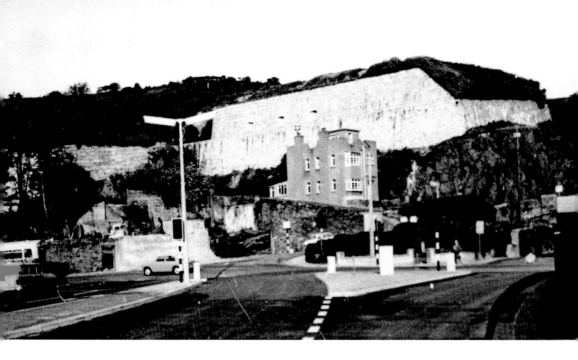

The A17 Road Tunnel, 1970 and 2011
Again, views taken at the Green Street end before and after completion of the A17 road tunnel.

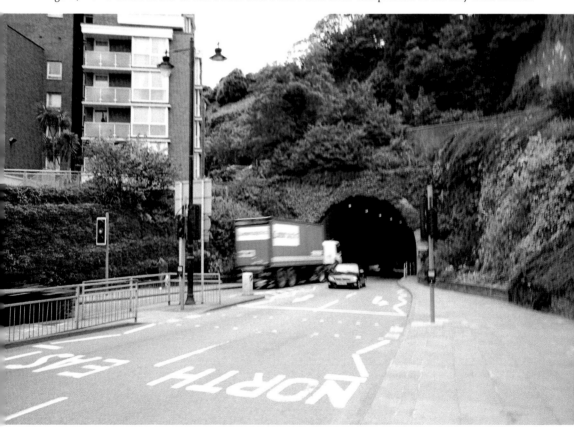

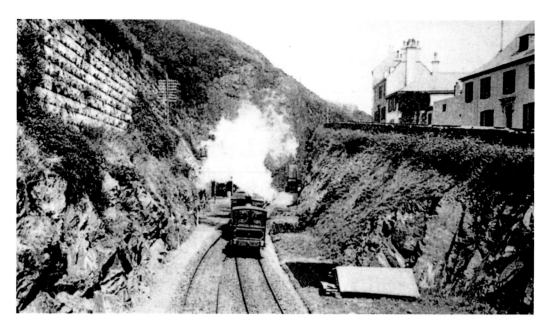

Snow Hill Station, *c.* 1922

Snow Hill Station, the terminus of the Jersey Eastern Railway at St Helier, *c.* 1922. The East Road Bridge crossed over the old railway line, which ran up the cutting behind Fort Regent. Today this is a public car park.

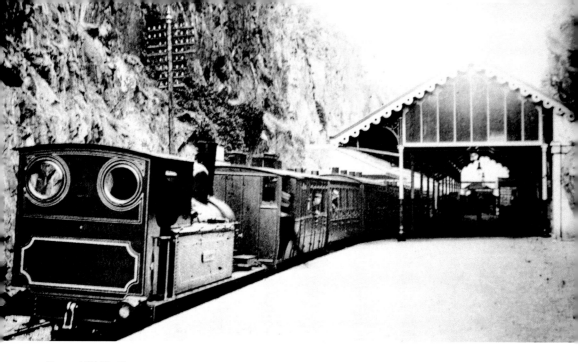

Snow Hill Station, *c.* 1922
Locomotive 0-4-0T *Carteret* waiting to leave Snow Hill Station for the journey to Gorey in *c.* 1922.
Now a car park, the concrete retaining walls are all that remain of the station today.

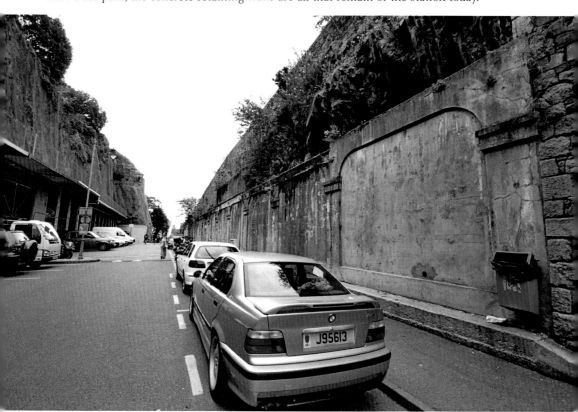

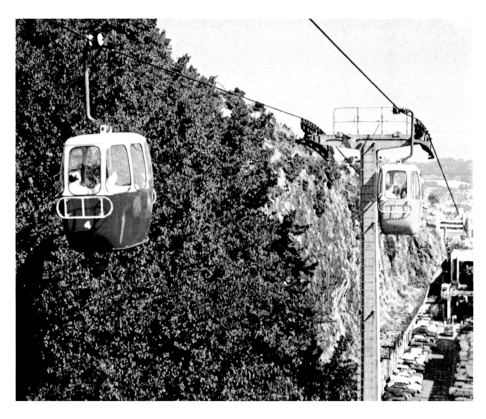

Fort Regent Cable Railway, *c.* 1960
At one time it was possible to access the leisure centre on top of Fort Regent via cable cars on the cable railway. Today, the only reminder we have of this unique form of transport is the old ticket office at the junction of Colomberie and Hill Street.

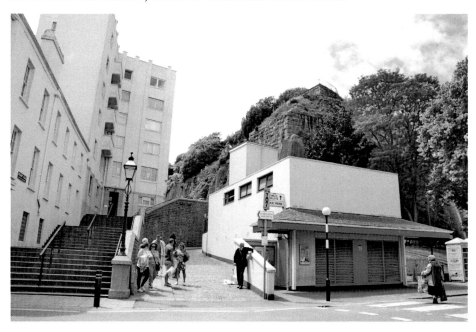

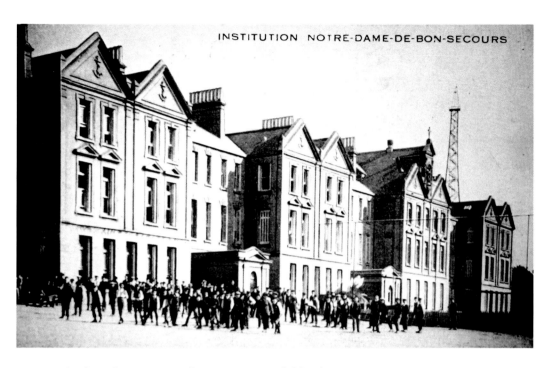

Institution of Notre Dame de Bon Secours, Highlands, c. 1894

Highlands College, Jersey, is situated on a campus in St Saviour on the site of the French Jesuit training school Notre Dame de Bon Secours. Originally based in Brest, France, the Jesuit school was established at the Highlands, Jersey, in 1894. After the First World War, another French group set up a missionary school on the site. During the occupation, the building was used to house German troops and did not restart as a missionary school until 1945. In 1970 the premises were sold to the States of Jersey, who in 1972 established Highlands College. Subsequently, the site has been expanded to incorporate all departments of further education on the campus.

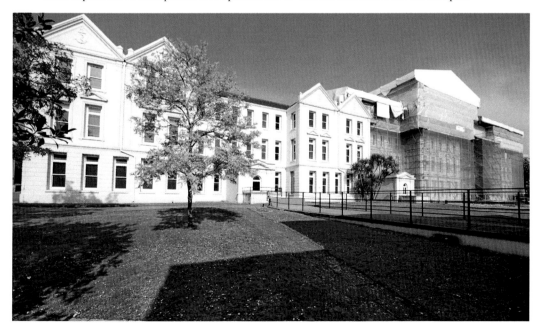

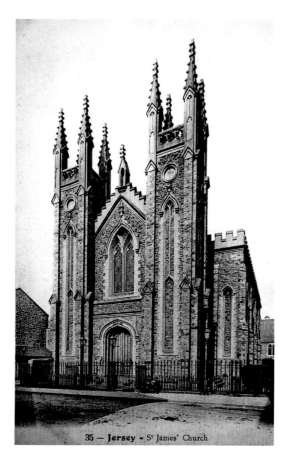

35 — **Jersey** - Sᵗ James' Church

St James' Church, c. 1900 and 2011
This fine view of St James' church is post franked 'May 1 05'. The church itself fronts onto St James' Street and is flanked by Le Breton Lane and Chapel Lane. Today the church is in a sorry state and almost unrecognisable, as it is encased in scaffolding.

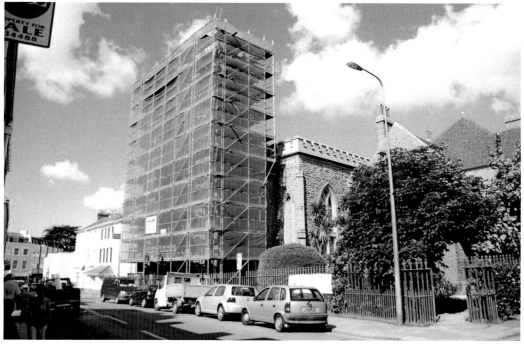

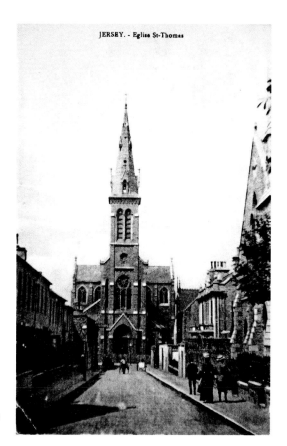

**St Thomas' Roman Catholic Church,
c. 1910 and 2011**
St Thomas' church, or Eglise St-Thomas, is captured on this postcard, which is date-stamped 'Aug 24 12'. Comparing this view with that of almost a hundred years later, little has changed.

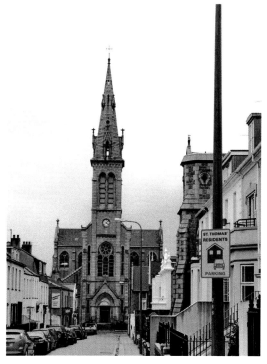

45

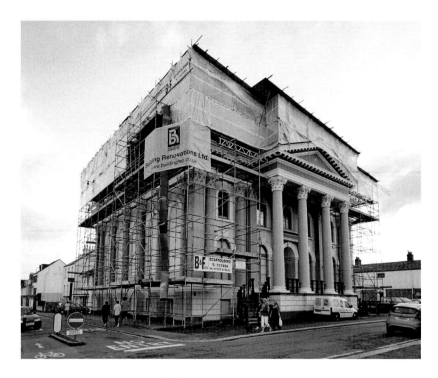

The Masonic Temple, Stopford Road, 2010 and 2011

The Masonic Temple is one of the most attractive and imposing buildings of its type to be found throughout the British Isles. Of brick construction with granite facings in Greek Corinthian style, it has a classical appearance enhanced by the beautiful detail that has been employed in its design. The commanding façade employs an entrance porch of four 26-foot-high columns with two staircases, one on either side, leading to the main entrance doors on the first floor. On 27 January 1941 the Temple was sacked by the German occupying force and was only restored to its former glory after access was regained to the building on 18 July 1945.

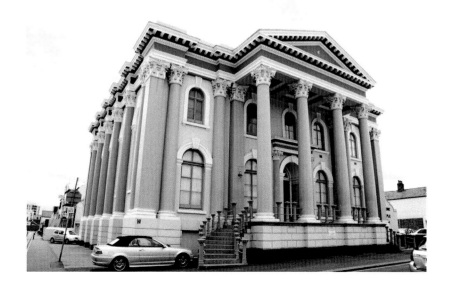

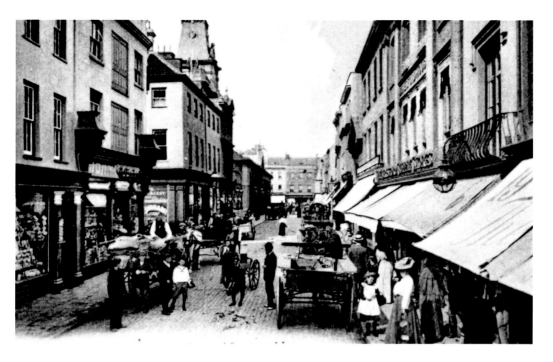

Beresford Street, c. 1920 and 2011
Beresford Street is on the north side of the market and dates from the 1820s. It is named after the last Governor of Jersey, one Lord Beresford who was a general in the Peninsular War and a marshal of the Portuguese army. The tall building with the tower is the Victoria Club. Traffic in the street appears to have been equally as busy and congested then as it is in 2011.

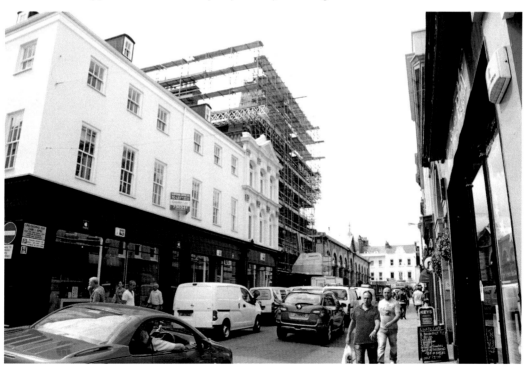

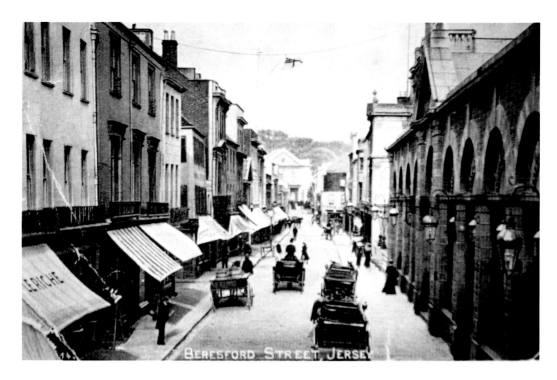

Beresford Street, c. 1920 and 2011
Looking east along Beresford Street from the junction with Halkett Place. The new market is on the right and bears a blue plaque (inset) stating that Halkett Place was named after Sir Colin Halkett, Lieutenant Governor 1821–30, who served with distinction at the Battle of Waterloo.

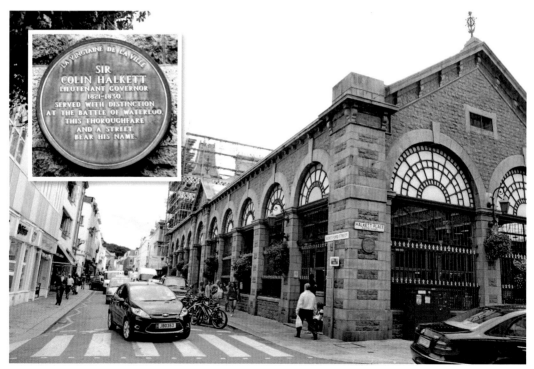

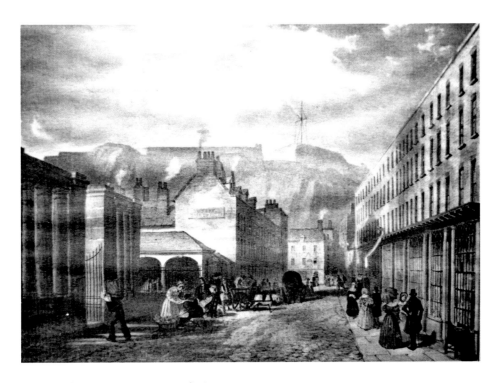

Halkett Place, Between 1838 and 1845

Halkett Place from a lithograph by William Day & Louis Haghe. The partnership, formed around 1830, became the most famous early Victorian firm of lithographic printers in London. They were appointed 'Lithographers to the Queen' in 1838. This coloured lithograph was produced between 1838 and 1845 before William Day died and the company name changed to Day & Son.

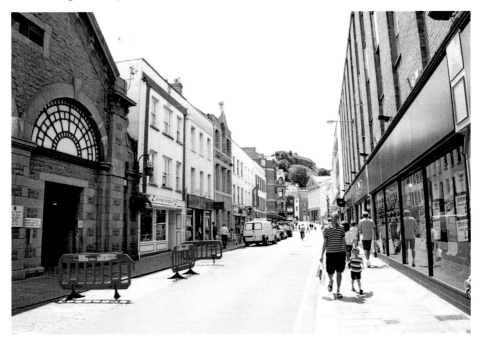

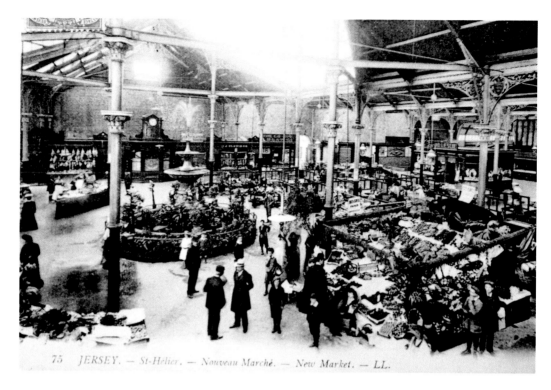

75 JERSEY. — St-Hélier. — Nouveau Marché. — New Market. — LL.

The New Market, Built 1882

The New Market was built in 1882 and is shown in the postcard view which is franked 'Aug 1911'. As can be seen from the 2011 photograph, the main cast-iron structure of the market hall and the ornate fountain have not changed over the years. Inset: Guess who is the real butcher?

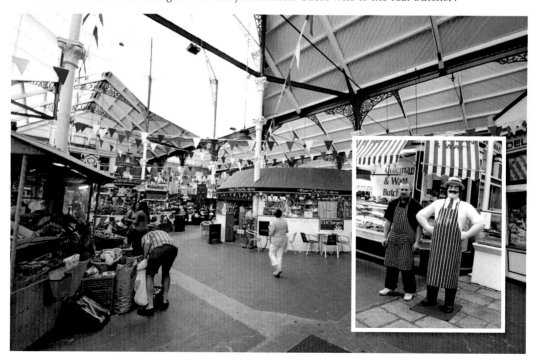

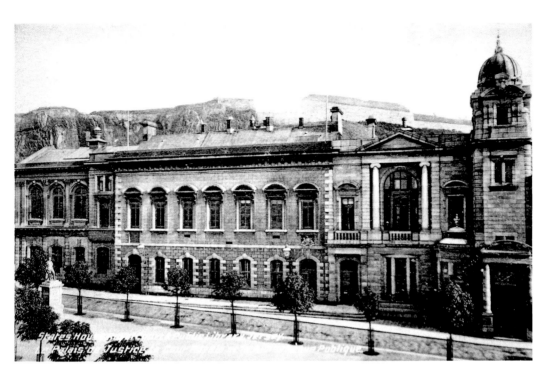

The Royal Square, c. 1894

The States House of Assembly (once part of the Royal Court) and the public library, c. 1894 when the chestnut trees were planted. The trees have now matured and obscure the buildings, as shown in the 2011 view. The Royal Square was the site of the Battle of Jersey. On 6 January 1781, Major Peirson, in command of the Jersey Militia, vanquished the French invaders. In doing so, he was mortally wounded and died a national hero.

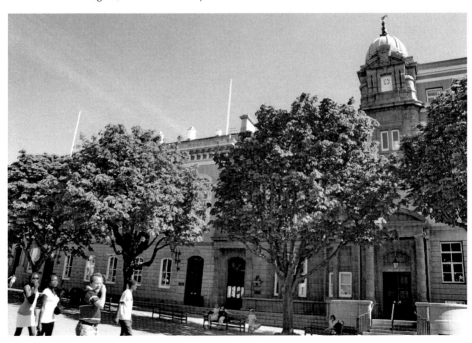

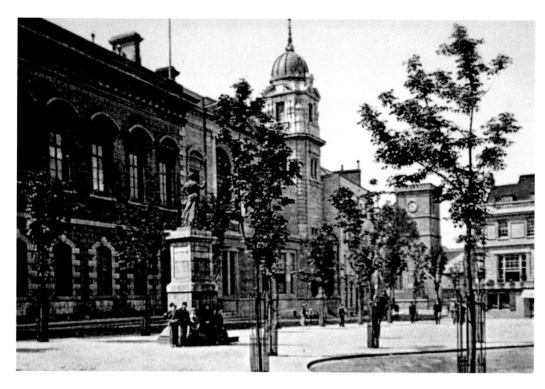

The Royal Square, c. 1894

Another view c. 1894 of the States House of Assembly, Public Library and Courthouse, this time looking towards St Helier's parish church and the United Club. Prominent in the picture is the golden statue of King George II by John Cheere which was erected on 9 July 1751. The name of the square was previously Le Marchi, the Market, but changed at this time to the Royal Square.

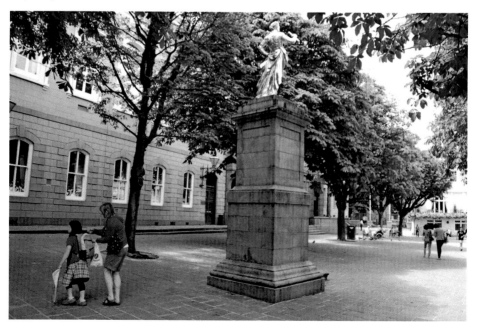

The Public Library, Royal Square, 1930s
This, St Helier's second public library, was opened in 1886. However, in order to make more efficient use of both the courthouse and public library, the latter was eventually moved to Halkett Place and opened there by the Queen in 1989.

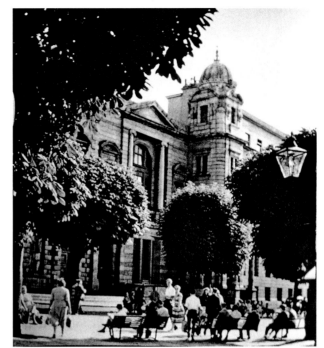

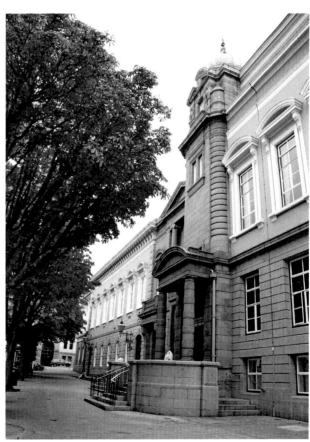

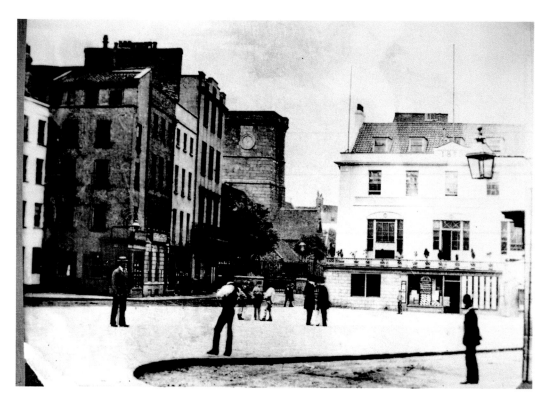

The United Club, Built in 1825

Looking west across the Royal Square to the United Club, which was built in 1825. Prior to this date, the site was occupied by La Halle à Blé (The Cornmarket) when the square was the market place. The square was paved in 1818.

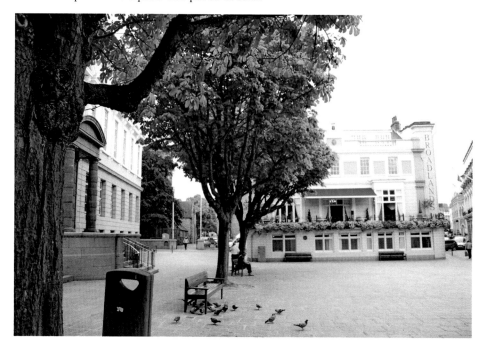

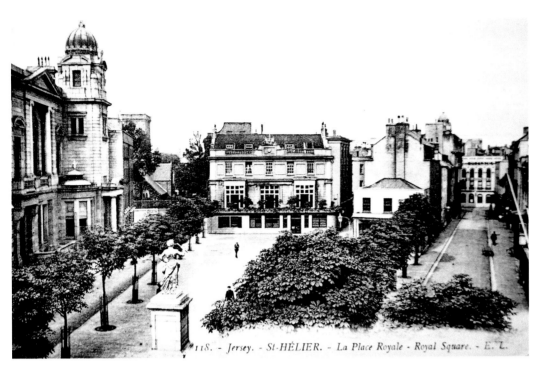

118. - Jersey. - St-HÉLIER. - La Place Royale - Royal Square. - E. L.

View of the Royal Square, c. 1900
A general view of the Royal Square
c. 1900. The building to the right of
United Club (centre) was formerly The
Piquet House, used by the Military
Police until 1924. As can be seen from
the accompanying photograph from
2011, Jersey Police still continue to
use the premises. Inset: The Piquet
House's blue plaque.

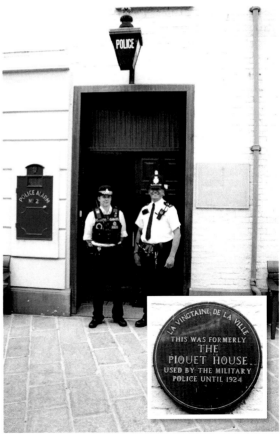

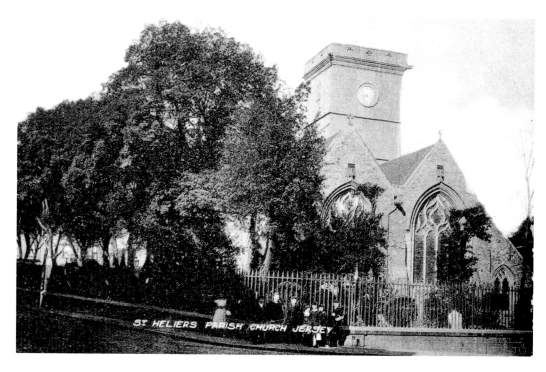

The Parish Church of St Helier, *c.* 1900 and 2011

Helier was a Belgian saint and hermit who lived for some ten years on an islet in St Aubin's Bay. He was killed in AD 555 by Saxon pirates and was subsequently martyred as St Helier. He was adopted as the patron saint of Jersey; its church and capital are both named St Helier. Thought to have been sited on an earlier chapel, building of the present parish church began in the eleventh century.

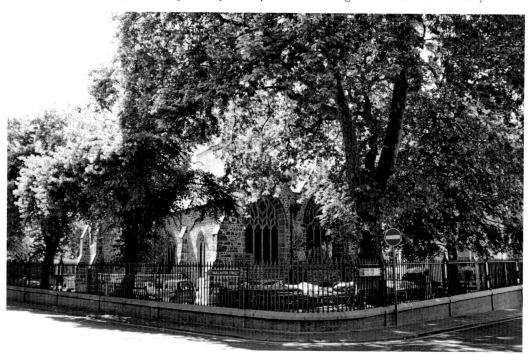

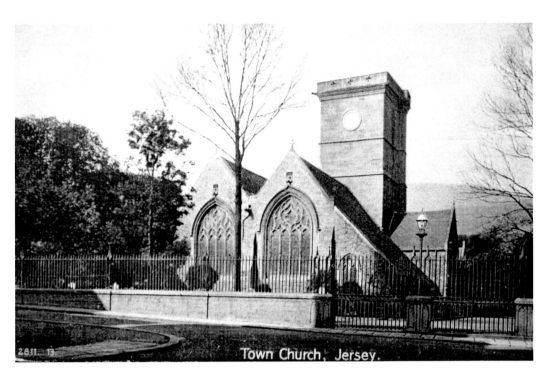

Town Church, Jersey.

The Parish Church of St Helier, *c*. 1900 and 2011
Although the parish church is some way inland today, it once lay on the seashore. In the distant past there were iron rings set in the church walls to tie up boats. These were lost when the south end of the church was extended during one of many changes made to the building. At one time, the church also housed the Parish Gun or Cannon.

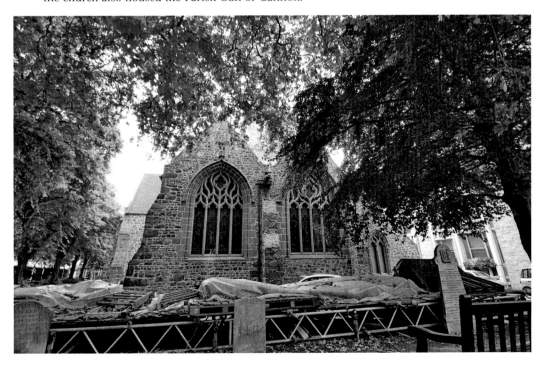

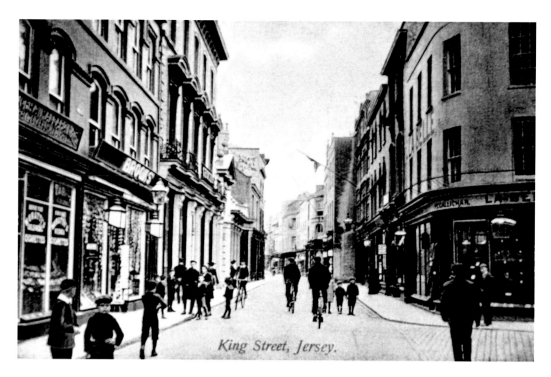

King Street, Jersey.

King Street, c. 1914 and 2011

Looking down King Street towards Charing Cross; the street has altered over the last 100 years. The shops and their styles have changed and so have fashions. The motor car, which made its presence felt for many years, has also come and gone!

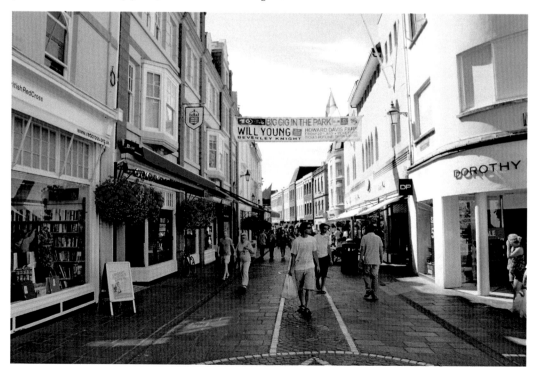

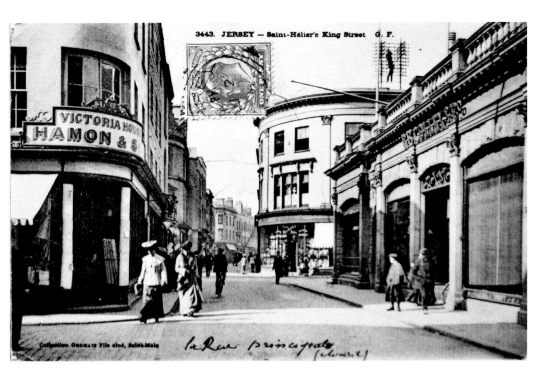

Hamon & Son, Victoria House, King Street, 1904 and 2011
A postcard franked 'Oct 1904', showing Victoria House on the corner of King Street and Bridge Street, which has housed a drapery shop since about 1845. Initially called Hamon & Son, this great old Jersey institution now trades as Hamons Ltd, but for how much longer? The owners indicated in March 2008 that they were winding down the business. However, at the time of this book going to print, Hamons Ltd was still there!

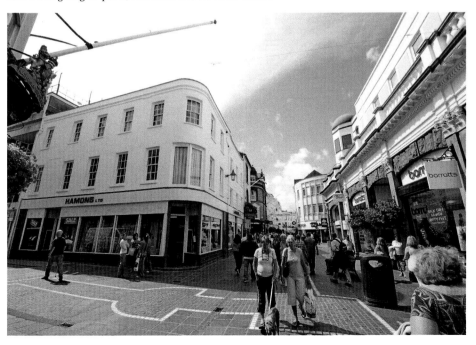

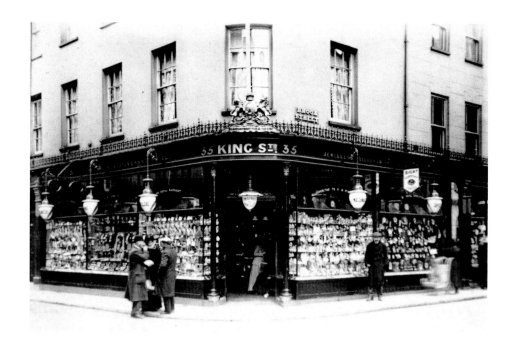

C. T. Maine, King & Brook Street, Christmas 1912 and 2011

C. T. Maine Ltd, the well-known Jersey independent family jeweller's, closed its doors at the end of 2009 after 113 years of trading, with the loss of 7 jobs. The business, which straddled the corner of King Street with Brook Street, on the opposite corner to Hamons, had been established in 1896 when it purchased the retail jewellers of 'John Le Gallais (Late of De Gruchy), Silversmith, Watch Maker & Jeweller'. The latter firm had occupied the same premises since the 1790s when silversmithing was carried out in the workshop of that company.

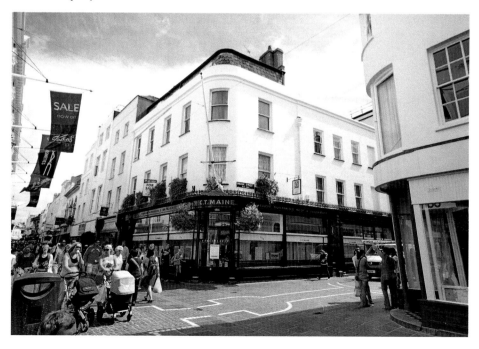

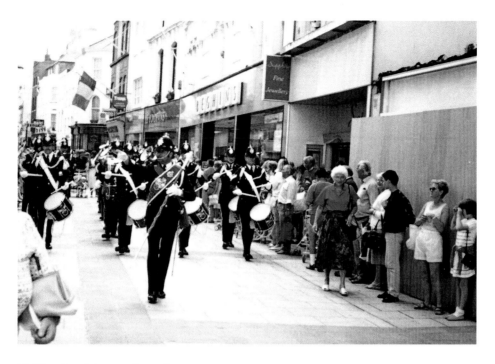

Visiting Band, June 1989 and 2011

At one time, it used to be very popular for bands to visit the island to play in the bandstand at Howard Davis Park. From there, they would march down Colomberie and into town via Queen and King Streets. Today, it is the Band of the Island of Jersey that has the honour of parading through the town centre to Royal Square, where they perform a concert and give a marching display.

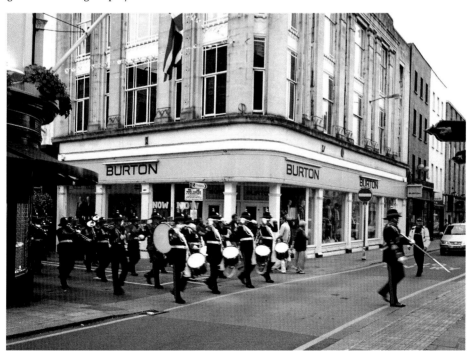

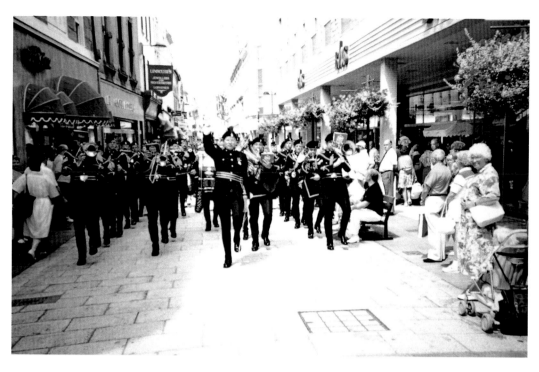

Visiting Band, June 1992
What looks to be a Tank Regiment Band, marching proudly through Queen Street and past BHS on 29 June 1992. The Band of the Island of Jersey marches past the same store on 15 August 2011.

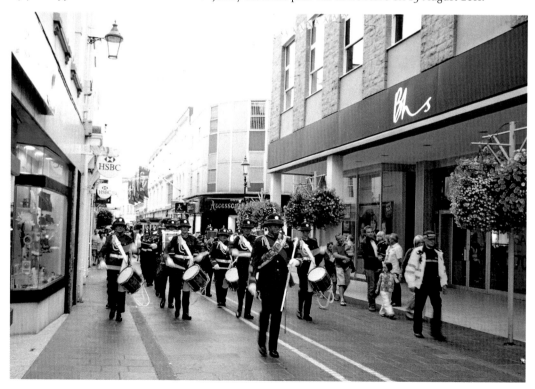

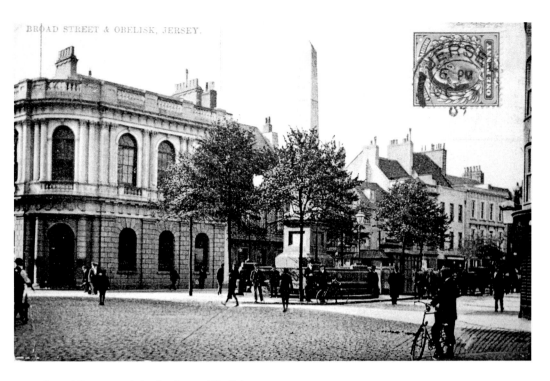

Broad Street and the Le Sueur Obelisk, c. 1900
This postcard of Broad Street and Le Sueur Obelisk is franked 'Jersey 6 PM OC 7 09'. It shows the Capital & Counties Bank, directly to the left of the Obelisk. In today's photograph, the view of this building, together with that of the general post office, which is behind the Obelisk, is largely obscured by the mature growth of the trees in the square.

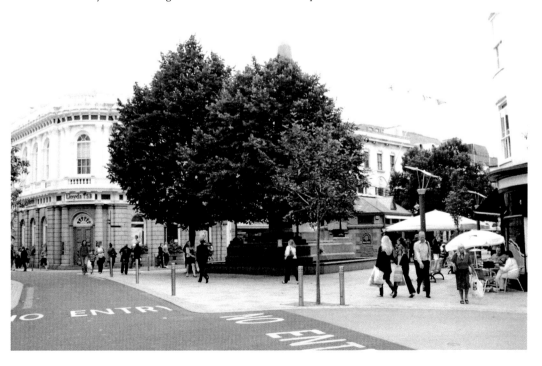

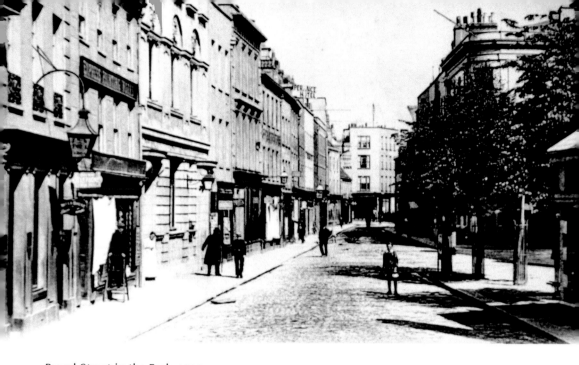

Broad Street in the Early 1900s
Another view of Broad Street, this time looking towards Charing Cross and the junction with King Street.

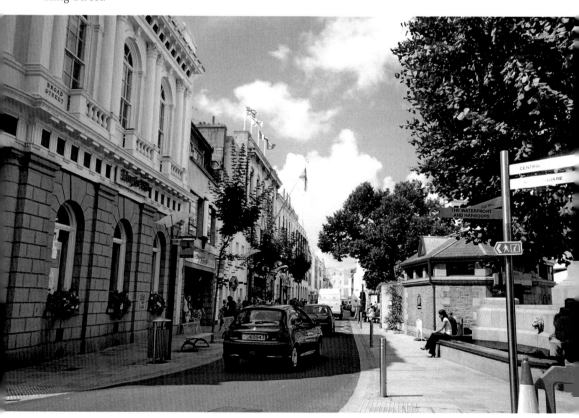

Larbalestier, *Eau de Cologne* Manufacturer, Established 1814
The founder of the perfumery, in 1814, was Philippe Larbalestier (1755–1861). The house was noted for its fashionable scents, especially *eau de Cologne*, and the establishment was one of the best known in Jersey for high-class jewellery and perfume. Since 1968, the premises at 2 Charing Cross have been occupied by an equally high-class jeweller, Aurum of Jersey. Inset: An example of a complementary postcard, which it was at one time common to hand out as an advertisement for a business. This one depicts Corbière Lighthouse which is the iconic emblem of Jersey.

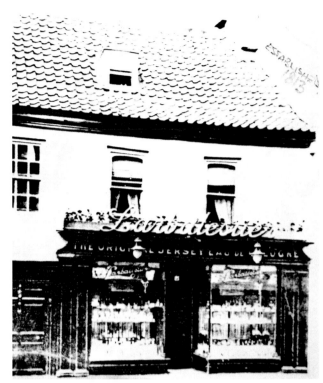

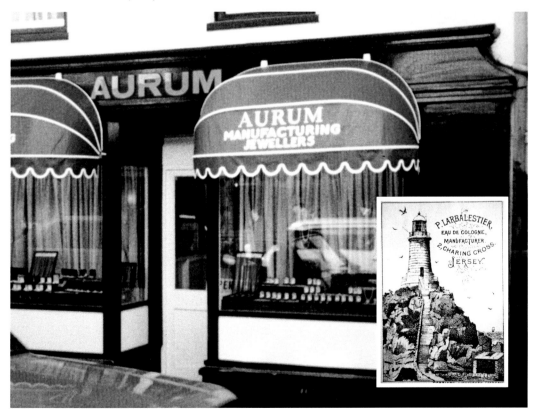

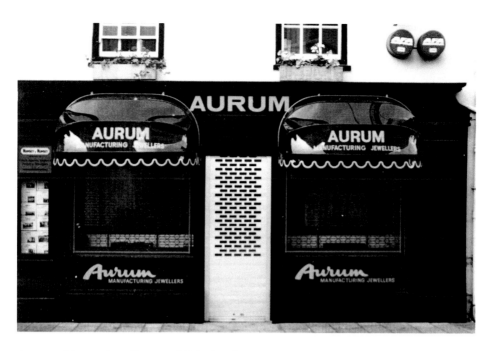

Aurum of Jersey, Jeweller, Established 1968

Aurum of Jersey established their goldsmith and jewellery enterprise in 1968 in what was once Larbalestier's perfumeries shop. After forty-two years, Aurum now has a busy shop and thriving workshop, with a reputation in both Jersey and London for the manufacture of high-quality fine jewellery. The busy shop is located at No. 2 Charing Cross and straddles the site once occupied by the Charing Cross Prison, the town's clink.

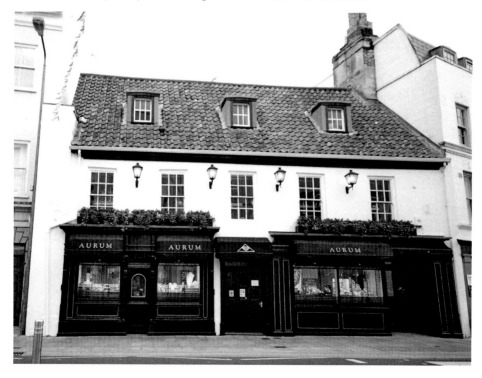

Queen Victoria's Diamond Jubilee, 1897
Celebrating Queen Victoria's Diamond
Jubilee in 1897 with a decorated archway
across Charing Cross – it would seem
many local inhabitants wished to be in
the photograph recording the event! The
Charing Cross Hotel can be seen through
the archway while the structure butts
directly onto the wall of Larbalestier's
shop. As a contrast, Richard Blampied,
proprietor of Aurum (centre front),
assembled his staff outside the premises
for a 2011 photograph to celebrate
forty-two years of successful business.

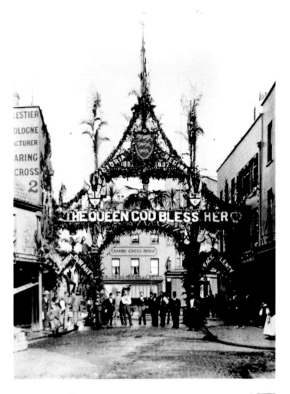

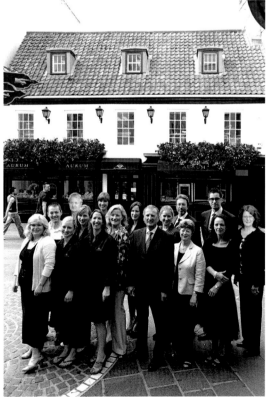

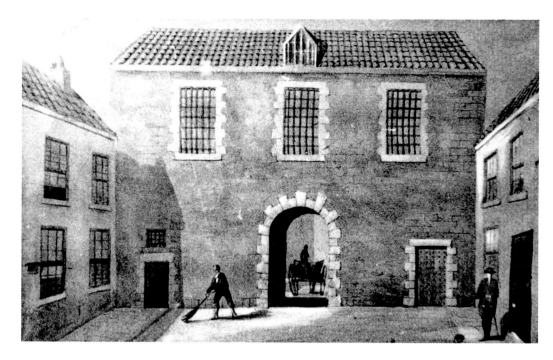

Charing Cross Prison, 1688–1814

The prison, a large, two-storey building with underground dungeons, was built over the road at Charing Cross. All traffic from the west had to pass through the prison archway. Assuming the man in the foreground was 5 feet 7 inches, the building scales off as 41 feet 6 inches wide, 25 feet 6 inches to eaves and 29 feet to roof ridge with the archway measuring 6 feet 4 inches wide by 11 feet 4 inches high. The photograph of 2011 gives a good impression of where the prison would have been located.

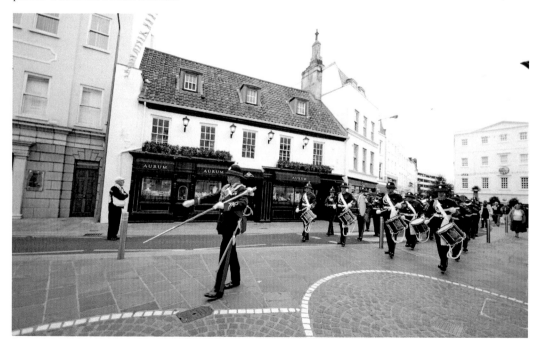

Site of Charing Cross Prison, 2011

Larbalestier's perfumery shop was built over part of the site of Charing Cross Prison after it was demolished in 1814. The underground dungeons still exist beneath Aurum the Jeweller and under the flats in the yard behind. They are not accessible having been cemented over when development took place. The two photographs show the yard and possibly the old town wall at the rear of Aurum the Jeweller, to where the dungeons would have extended.

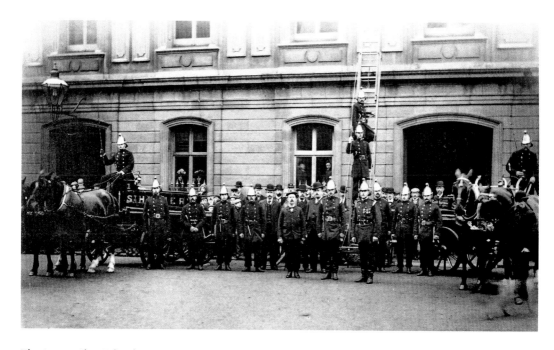

The Jersey Fire Brigade, 1902

The Jersey Fire Brigade was formed in 1900 and moved into the new fire station at the Town Hall on 1 January 1902. The picture shows the brigade lined up for the inauguration ceremony. This was followed by a drive around town and display which included a simulated rescue from the roof of the Town Hall. The fire station is no longer in the Town Hall, but in a purpose-built complex constructed at Rouge Bouillon in 1954.

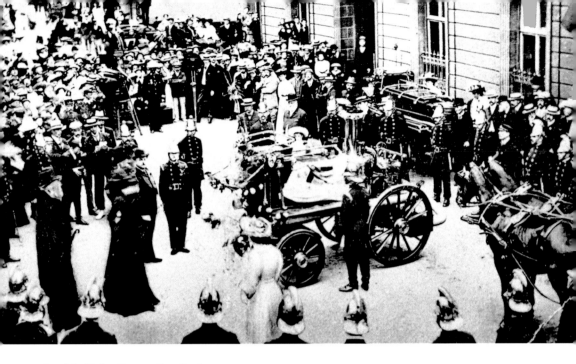

Lord St Helier Steam Fire Engine, 1905

On 30 July 1905, at a ceremony outside the Town Hall, the inauguration of Jersey's first steam fire engine was carried out by Miss Baudains who christened the new machine, the *Lord St Helier*. This fire engine provided an excellent service until replaced by the first petrol-engined, brand-new Dennis fire engine in 1923.

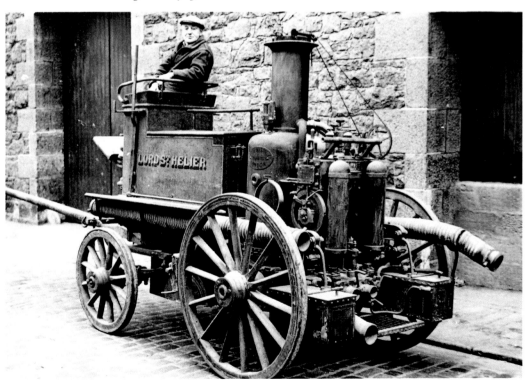

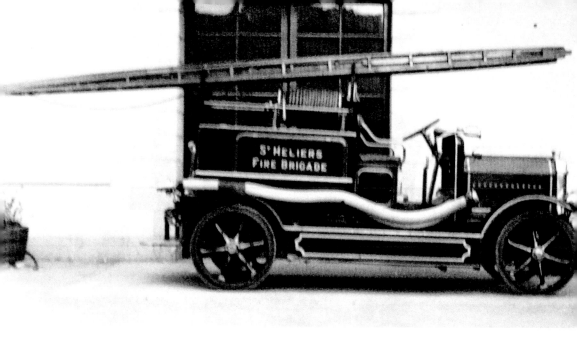

New Fire Engines, 1923 and 2011
The new Dennis fire engine that arrived on the island in 1923 and an example of one of today's fire engines at Rouge Bouillon in 2011, with firefighter Astal-Stain in attendance.

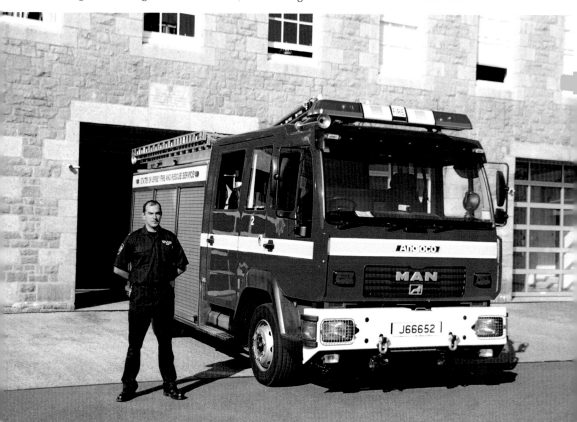

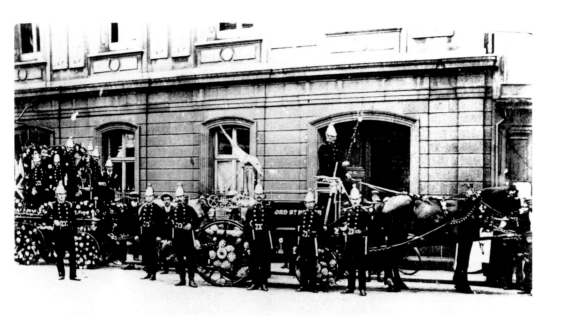

Jersey Fire Brigade Appliances, 1905 and 2011

Horse-drawn fire appliances lined up outside the Town Hall Fire Station ready for the 1905 Battle of Flowers, and the full complement of modern firefighting vehicles at the Rouge Bouillon Fire Station in 2011, captured by photographer Alexis Militis. Inset: Crew Manager Jason Betts demonstrates how to use the greasy pole. The fire station at Rouge Bouillon is the only location left in the United Kingdom to have greasy poles.

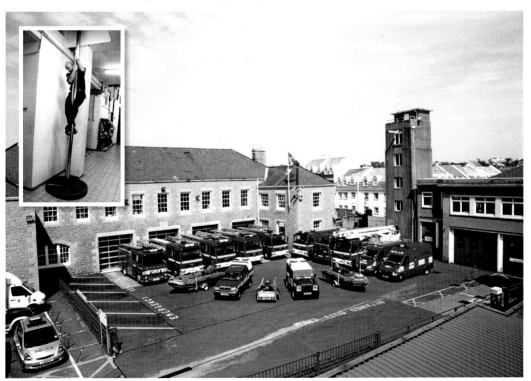

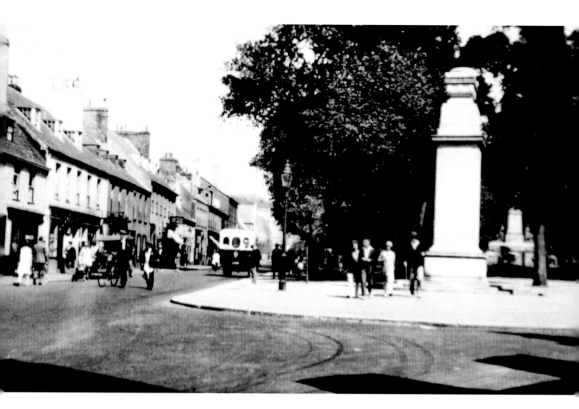

The Cenotaph, The Parade, St Helier, 1930s and 2011
Two views of the Cenotaph: one vintage shot taken in the 1930s, while the other from 2011 shows very little change in the intervening years.

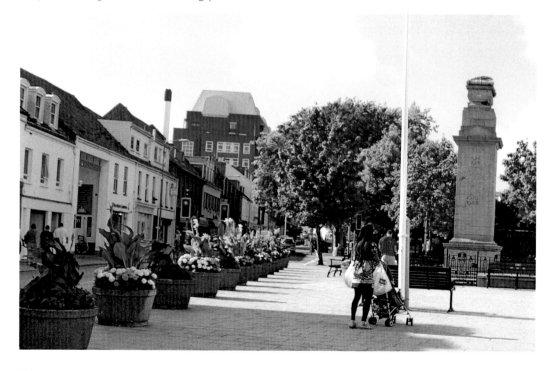

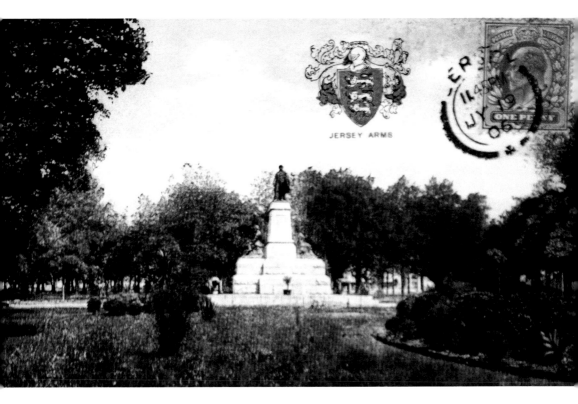

JERSEY ARMS

The Don Monument, The Parade, St Helier, *c.* 1900 and 2011
The coloured postcard showing the Don Monument is clearly franked 'Jersey JY 19 1906'. Again little has changed except for the repositioning of the guns and the extension of the garden around the base.

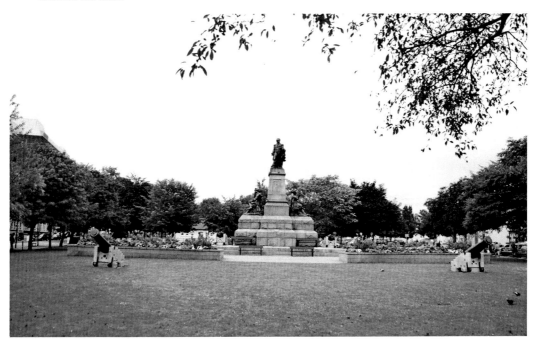

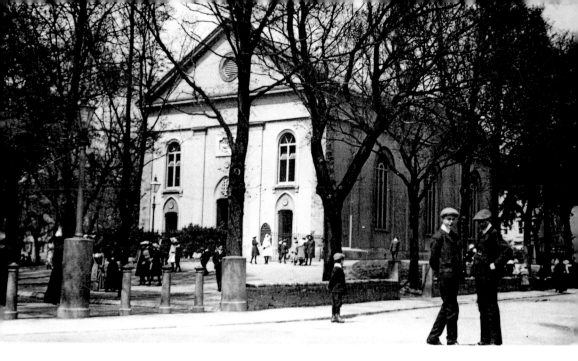

All Saints' Church, The Parade, St Helier, *c.* 1900
All Saints' church, on the junction of Elizabeth Place and Saville Street, in about 1900 and 2011. Little has changed except that the trees have matured and thickened.

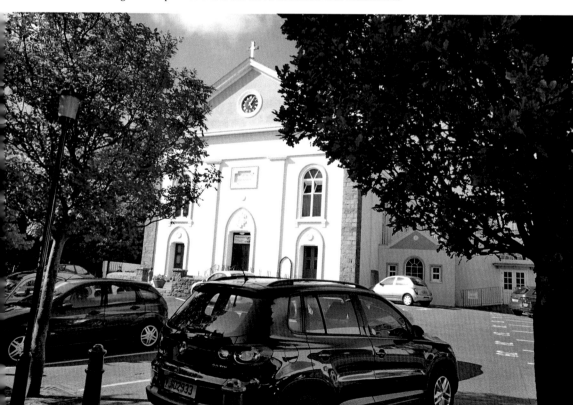

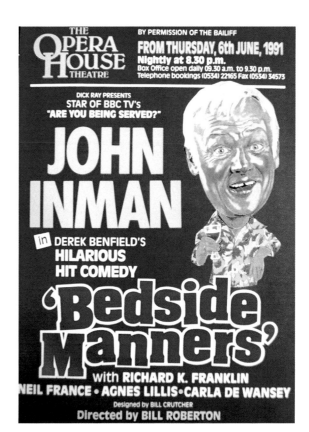

The Opera House Theatre,
Gloucester Street, St Helier
John Inman, in *Bedside Manners* in
1991. By permission of the Bailiff, he
was a regular visitor to Jersey and
performed many times in the Opera
House Theatre, Gloucester Street.

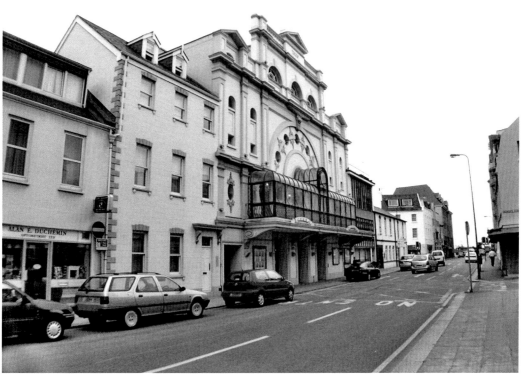

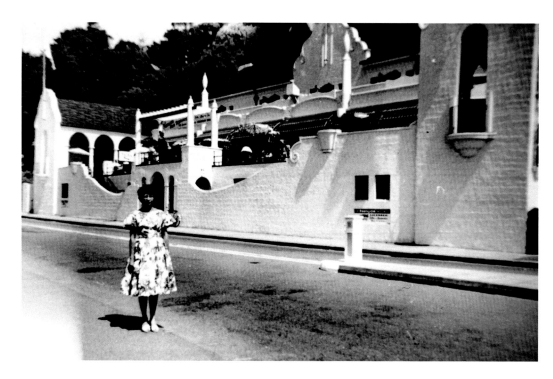

The 'Pav', West Park Pavilion, June 1960

A young Malvina Morgan posing in front of West Park Pavilion in June 1960. Originally built in 1886 as 'The Tin Shack' for a circus, it has been a skating rink, a concert hall, a ballroom, a cabaret and live gig venue, and finally a rave disco. As the 'Inn on the Park', it closed down for good in 1996 and was demolished in 1998/99 when a start was made on building a new apartment block in its place.

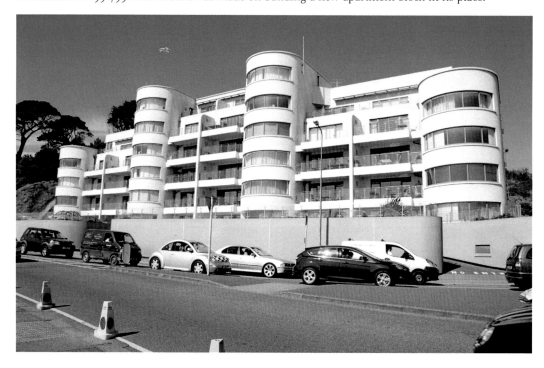

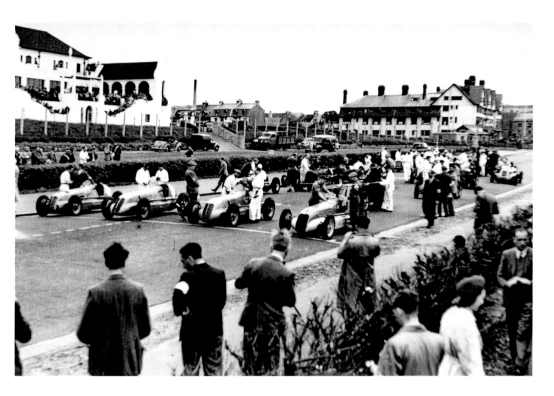

Jersey International Road Races, 1947–52

After the Second World War, there was no venue for the British Grand Prix. Jersey was selected for this event using a circuit from West Park to Bel Royal along Victoria Avenue returning via St Aubin's Road, a total of just over 3 miles. The photograph shows the line-up of cars at West Park Pavilion for the first road race in 1947. As a contrast, today's races are held on the beach at West Park.

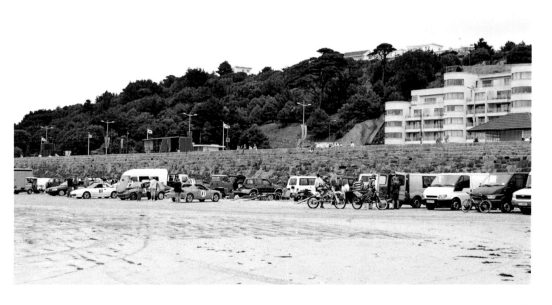

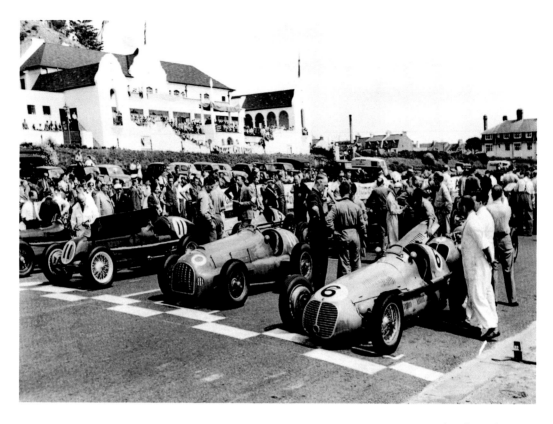

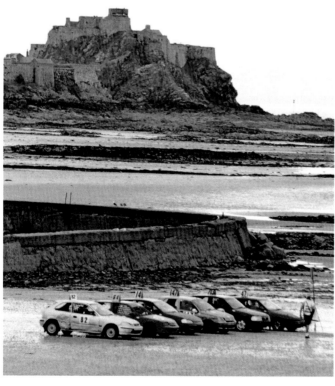

Jersey International Road Race, 1950 and 2011
Cars lined up on the grid in front of West Park Pavilion for the 1950 race and on the beach for Sand Racing in 2011.

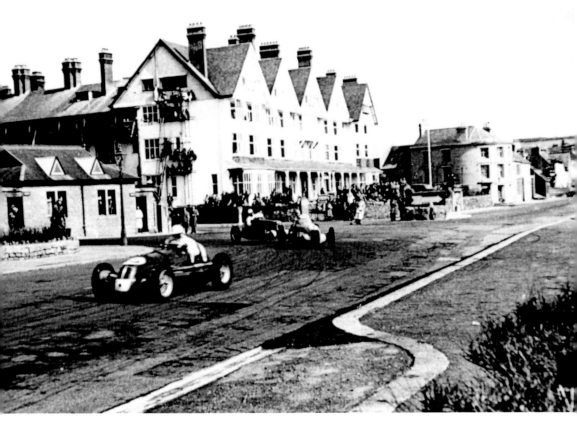

Jersey International Road Race, 1948 and 2011
Rounding the corner at the Grand Hotel in the 1948 International Road Race and going flat out
on the beach at West Park during the 2011 Sand Racing season.

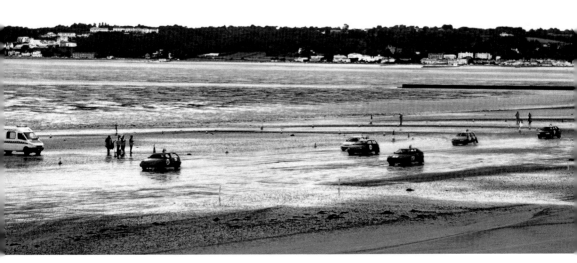

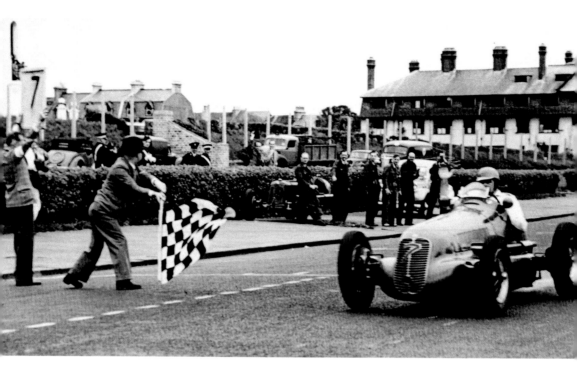

Jersey International Road Race, 1947 and 2011
Reg Parnell, the British driver in a Maserati, crosses the line and gets the chequered flag to win the 1947 race. Equally exciting, sand racing on West Park Beach in 2011 is not without its thrills and spills.

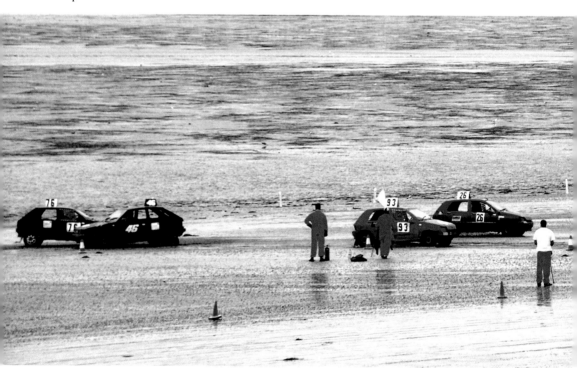

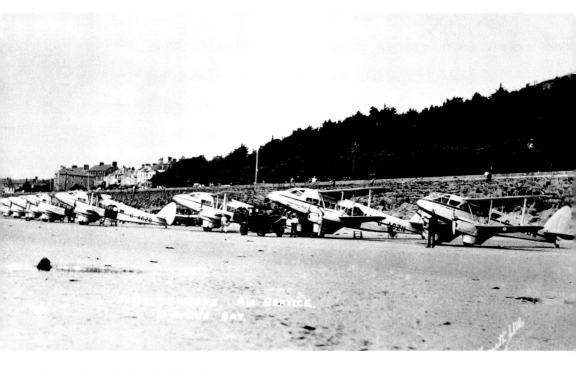

Jersey Airport West Park Beach, 1933–37
An assortment of eight De Haviland DH84 Dragon and DH86 Express short-haul passenger aircraft lined up on West Park Beach in 1934. Jersey's Airport was here 1933–37, until the new aerodrome was built at St Peter's. The nearest an aircraft gets to West Park today is when the annual International Air Display takes place. Here we see a Catalina amphibious sea plane flying in over Elizabeth Castle during the 2005 show. Inset: Not a bit like the high security we experience in today's air terminals, the airport on the beach was just an extension of this bobby's beat.

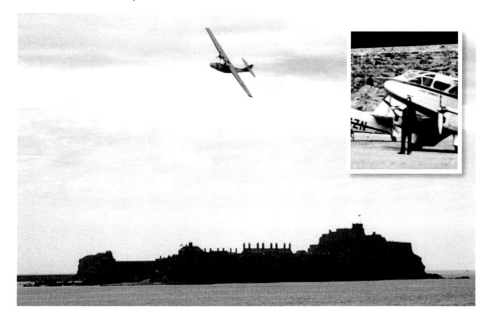

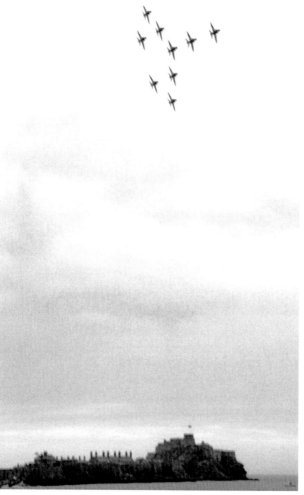

Dragons on the Beach, 1934
De Haviland DH84 Dragon
short-haul passenger aircraft on
the Beach at West Park in 1934.
A far cry from the Red Arrows
performing over Elizabeth
Castle in St Aubin's Bay during
the air display in 2005. The 2011
show was cancelled due to bad
weather. The Red Arrows, who
were due to perform, have not
missed an air display in nearly
fifty years.

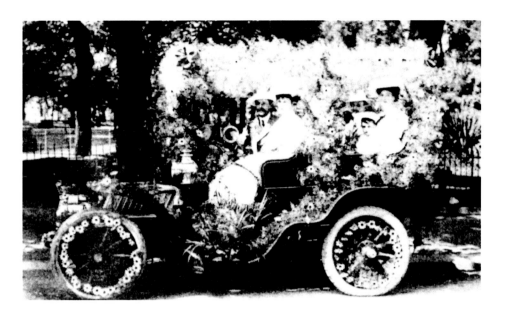

Battle of Flowers, 1910 and 2011
A scene from the 1910 Jersey Battle of Flowers. The initial Battle of Flowers was held eight years earlier in 1902 as part of the local festivities organised to celebrate the Coronation of King Edward VII and Queen Alexandra. The Bailiff of Jersey, Michael Birt, was celebrating sixty years of continuous Battle Parades on Victoria Avenue as he paraded in his carriage before opening the 2011 Battle of Flowers.

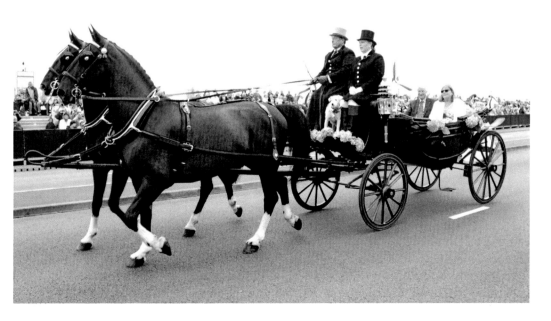

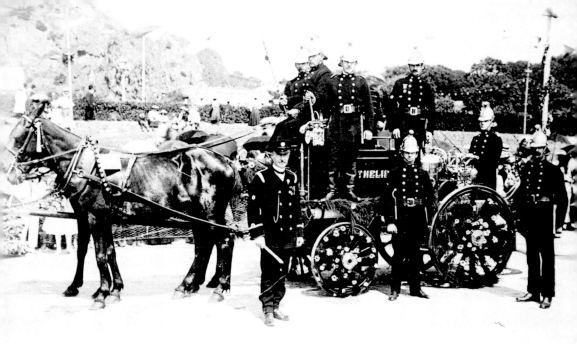

Battle of Flowers Exhibits, 1905 and 2011
The *Lord St Helier* steam fire engine, with Chief Officer H. Eady and crew, decorated as an exhibit for the August 1905 Battle of Flowers; quite a contrast to the modern fire engine and 'mascot' taking part in the 2011 Battle of Flowers Parade.

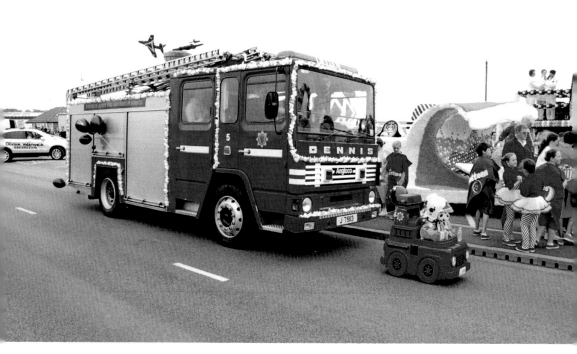

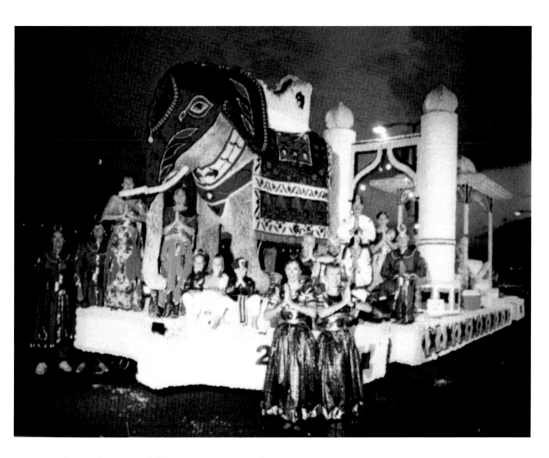

Battle of Flowers Exhibits, Yesteryear and 2011
Batman's adversaries on the Parish of Trinity 2011 Battle of Flowers float.

Battle of Flowers, Yesteryear and 2011
'Go West, young man!' The coal-burning, smoke-belching and gun-toting *Prairie Express*. Left, visitors Pauline and Joan join in the fun and get up close to the action.

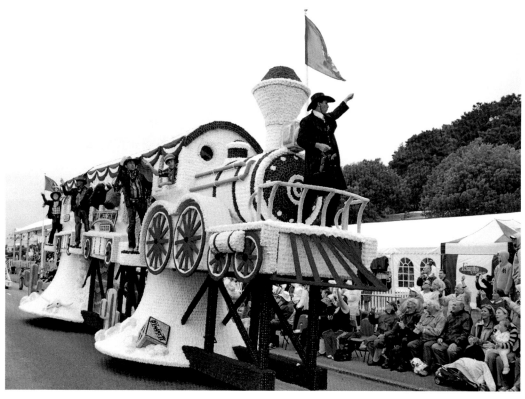

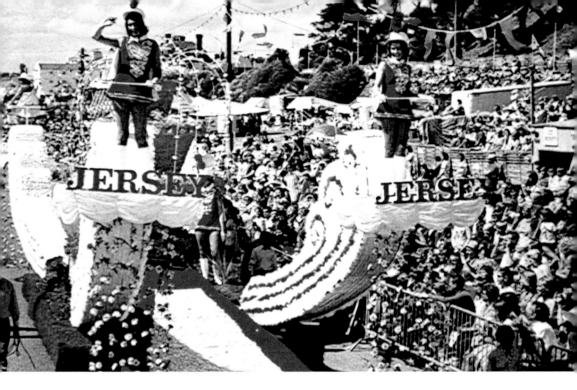

Battle of Flowers, Yesteryear and 2011
Hiawatha comes to town complete with wigwam, buffalo and band of Indian braves!

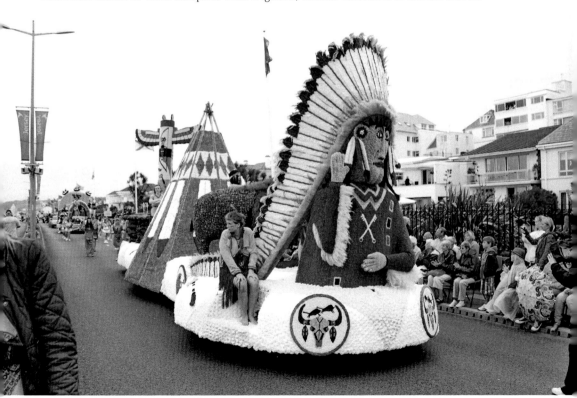

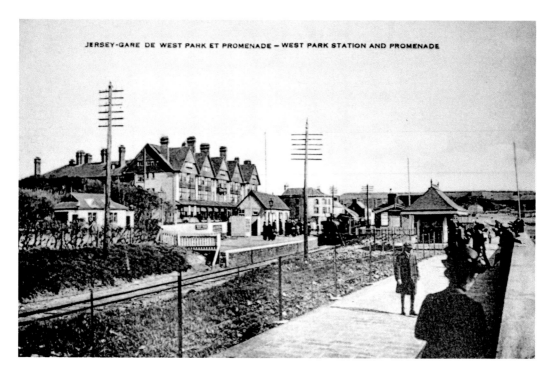

JERSEY-GARE DE WEST PARK ET PROMENADE – WEST PARK STATION AND PROMENADE

The Promenade and West Park, After 1890
Looking east along the Promenade with West Park Railway Station in the foreground and the Grand Hotel behind. The foundation stone for the latter hotel was laid in 1890. The railway has long since gone and the Esplanade and Promenade have been extensively widened.

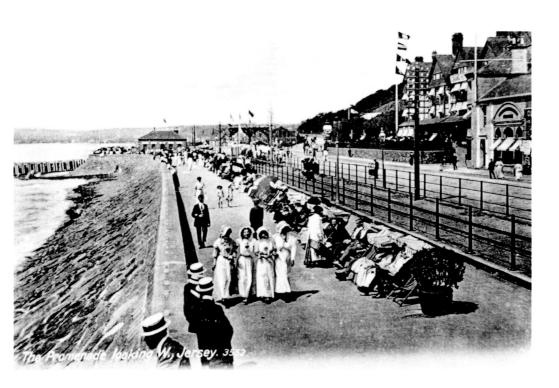

The Promenade and Esplanade, After 1890

Another view of the Grand Hotel, but this time looking west. The railway line is quite prominent dividing the Promenade from the Esplanade and the photograph was obviously taken in a more leisurely time when it was customary to 'promenade' like the four well-dressed young ladies. Today, the Esplanade is much wider as the railway has gone and the Promenade still attracts plenty of walkers and cyclists.

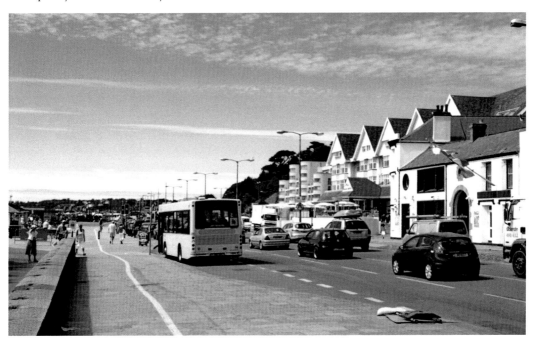

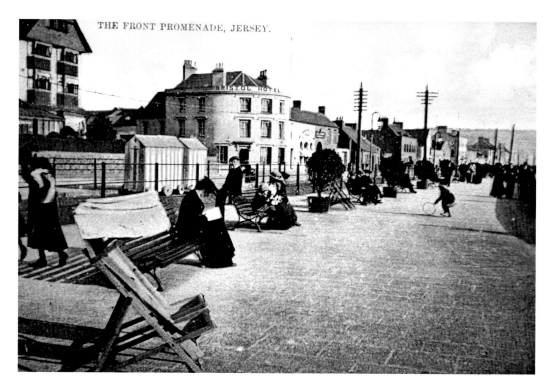

The Promenade and Bristol Hotel, c. 1900

Comparing the two views, the Jersey Railway closed in 1936 and the track was incorporated into widening the main road – the Esplanade. The width of the Promenade appears to be unchanged as are the buildings fronting the Esplanade. The Bristol Hotel that was once housed in the cream-painted building on the corner with Kensington Place has gone.

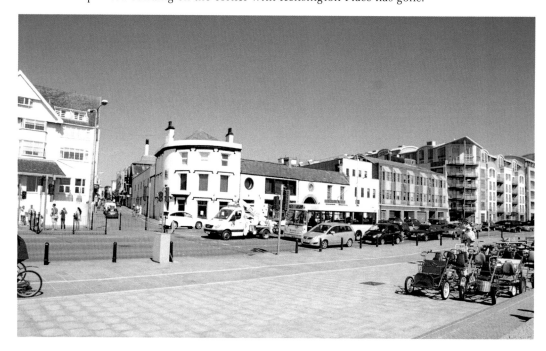

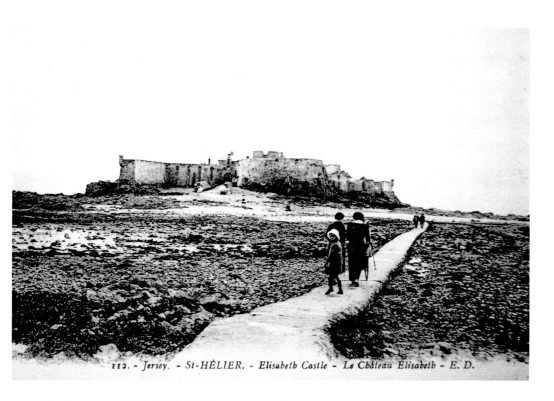

112. - *Jersey. - St-HÉLIER. - Elisabeth Castle - Le Château Elisabeth - E. D.*

The Causeway to Elizabeth Castle, *c.* 1900 and 1995

Little has changed between the early 1900s and the present day in the way visitors access Elizabeth Castle on foot. Here are sisters Jacqueline and Malvina on the causeway in June 1995 *en route* to Elizabeth Castle, with a DUKW in the background.

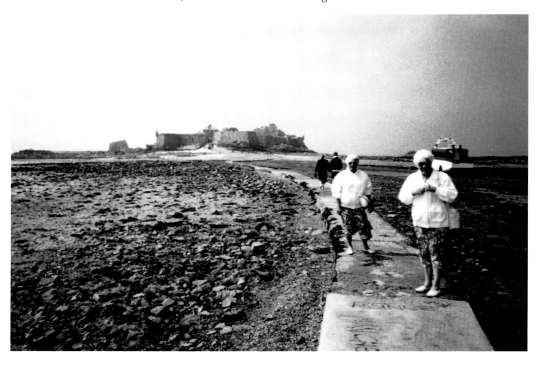

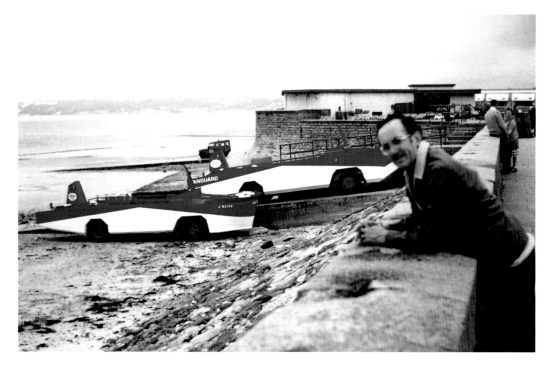

DUKWs or Puddle Ducks?

The vehicles shown in the June 1987 photograph were based on the amphibious 'DUKW', a Second World War US Army vehicle that could drive on land or water. They were ideal for transporting visitors to and from Elizabeth Castle, going either over the sand or by water when the tide was in. They later became affectionately known as 'Puddle Ducks', but were replaced in 2007 by purpose-built aquatic vehicles as shown in the 2011 photograph.

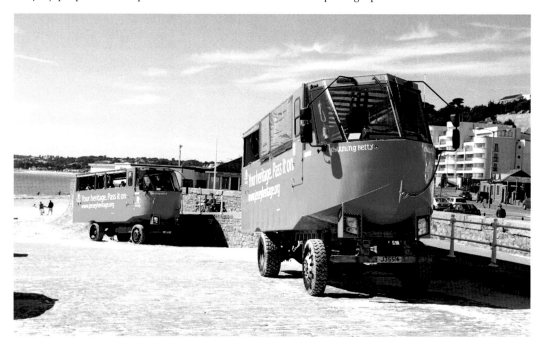

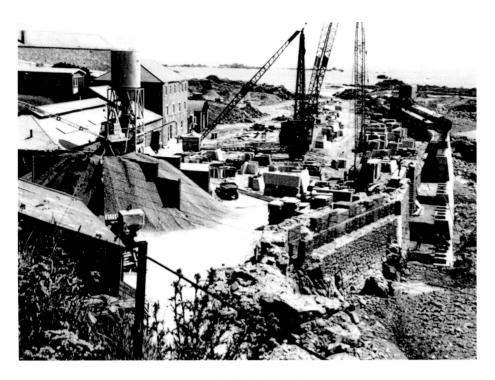

Construction of Elizabeth Harbour and Elizabeth Marina, 1980s

Built to accommodate fast ferries and freighters, Elizabeth Harbour was opened by the Queen in 1989. The Elizabeth Marina, which Prince Andrew opened in 1998, provides facilities for 570 berths. Typical of the modern development taking place in Jersey, the Waterfront, which fills the horizon in the 2011 photograph, houses the five-star Radisson BLU Hotel (opened 2007), a fitness centre, cinema complex and swimming pool, together with many restaurants and bars.

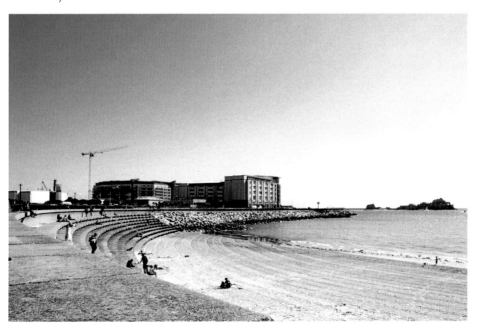

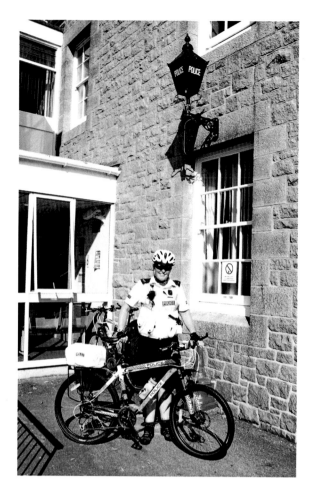

Highway Patrol, Jersey Constabulary
A police constable on one of the new mountain bikes introduced for Jersey Constabulary patrol duties in 2011.

Acknowledgements

Compilation of this book would not have been possible without all the help and support that I have received from the following organisations and individuals, for which I offer my sincere thanks and gratitude:

Richard Blampied and staff of Aurum Manufacturing Jewellers; Richard Smale and staff of The Old Court House Hotel, Gorey; Anna Baghiani of the Société Jersiaise; Liz Vivian and Lyndon Pallot of the Pallot Steam, Motor & General Museum; Chief Fire Officer Mark James, Crew Manager Jason Betts and firefighter Astal-Stain of Jersey Fire & Rescue Service; Jackie Gully of Jersey Tourism; Anthony Scott Warren and Geraint Jennings of L'Office du Jèrriais; photographers John de Garis, Alexis Militis and Mike Stubbs; collections of the late Dennis Holmes and the late George A. Rogers; individuals Paul Winch; Maria Gouveia; Karen Hardie; Jamie Lee O'Neill; Valerie Pinel; Michelle Cudlipp; Georgie Mabbs and, last but not least, Lauren Richards, apprentice photographer.

Please accept my apologies if I have inadvertently missed out anyone from the above list.